DIARY OF A

DEY ST.
AN IMPRINT OF WILLIAM MORROW PUBLISHERS

MADMAN

THE GETO BOYS, LIFE, DEATH,
AND THE ROOTS OF SOUTHERN RAP

BRAD **SCARFACE** JORDAN

AND BENJAMIN MEADOWS-INGRAM

DEY ST.

HarperCollins books may be purchased for educational, business, or sales promotional use. For information please e-mail the Special Markets Department at SPsales@harpercollins.com.

FIRST EDITION

Designed by Shannon Plunkett

Library of Congress Cataloging-in-Publication Data has been applied for.

ISBN 978-0-06-230263-2

15 16 17 18 19 OV/RRD 10 9 8 7 6 5 4 3 2 1

CONTENTS

FOREWORD

Calling Brad Jordan a genius is simply just too lazy. It's overstood. I always call him by his government and given name because if the name Jordan typifies greatness in sports and culture today, then this Jordan of rap clearly is that cat. The dude is also Thelonious Monk reincarnated in spit.

He gives off the impression that he is just merely squeezing the surface of his skill sets from his vast mind. It's hard to tell what is swirling next in his hip-hop vision and that unpredictability has led to pioneering the Trill ground of Houston, Texas, and the whole damn South for that matter.

I remember speaking at a university in Kansas City in 1990 at the beginnings of my lecture circuit career. After the event, my rap crew buddies Daheeteus and JLee of the Heet Mob took me to a party where the DJ played this new record he'd just gotten at least six times—Geto Boys, "Mind Playing Tricks on Me." I had embraced the Geto Boys in my first tour travels to HTown. In the hotel lobby, post-concert, usually it was DJ Ready Red and Bushwick Bill who stood out. Mr. Willie Dennis also became a friend of mine. The PE crew and I were fans of his out front, confrontational style. I got to know them better while touring together later on, including the usually quiet "Scarface." Usu-

ally in the background and cordial, still, it seemed like there were three dudes in the same body. That's when I simply started to call him Mr. Brad Jordan.

Mr. Brad Jordan's achievements since those early days are folklore now, lyrical lines of legend. As Baird "Flatline" Warnick, the curator of my site, Hiphopgods.com (@hiphopgods), says, Scarface has lyrics that you can feel—and wear.

It could be said that Brad Jordan is one of the best to ever do it. It could be said he's the realest and the truest, and that he's one of the greatest to ever touch a mic. This could be debated all day long, but what can't be debated is the enormous impact he's had on hip-hop culture from day one. What also can't be debated is that he is a true artist, one who approaches hip-hop as what it truly is at its core—ART. And therein lies my comparison to Monk.

Brad Jordan is an artist with words as a tool or a weapon. With laserlike precision he is able to craft entire songs and albums, as part of the Geto Boys or on the solo tip, unlike anyone else. He can put the fear of God in you, turn around and uplift you, then take you down a path that you never saw coming. He can put fear into your heart and also touch your soul at the same time. He can take you on a journey to the dark side and also bring you to the light. That is the beauty of what he does. There is so much to him, so many layers to peel back as an MC, as an artist, and as a man. Hip-hop needs more artists like him, but he is a true original.

The longevity, the ability to produce such a huge body of classic work is staggering and yet, should come as no surprise. His work ethic and dedication to his craft is unparalleled in an industry where you're here today and gone tomorrow. Singles and albums by Scarface are always met with the highest level of anticipation because, as a fan of the man, you know he will always deliver. You also have to wonder

what kind of jewel or quotable lines he might say next. Those who take the time to listen are rewarded every time, and looking back on his career, the track record proves itself. Classic albums recorded as part of the Geto Boys are essential listening, while his solo projects prove time and time again why he is considered one of the greats, and we should celebrate that. We should celebrate how he is able to fly the flag for hip-hop music, how throughout his career he's been able to make an impact far greater than just being a rapper from the South.

Forget Stephen King, in hip-hop and rap Brad Jordan is bigger than that, he has created and crafted timeless music, kicked down the doors in the name of hip-hop and he demands respect.

—Chuck D

DIARY OF A MADMAN

INTRODUCTION

My life happened so fast. One minute, I'm in the hospital depressed, and the next minute I'm at James Prince's ranch recording an album with a bunch of motherfuckers I hardly know. One minute, I ain't got a dime in my pocket; the next minute I'm buying houses and cars on fucking credit cards. One minute, I'm just another nigga with no father from the Southside of Houston, Texas; the next minute, motherfuckers are calling me the Godfather of Southern Rap (whatever that means). I came from the least of the least and I've had the most of the most. But more than anything, I am you. If you don't know me, or my career, or who I am or what I've done, that's what I'd tell you: I am you. I'm the way you think and the way you feel; the things you've seen and loved and the things you've seen that you can never unsee. I'm your hopes and your fears, the quiet, dark moments that house the secrets that you hold tight deep at night and the loud public moments that grip and rip your block in broad daylight. I'm the pain and the progress, the sadness and the celebration, the dream and the nightmare. I am you. I am your voice. I am the voice of the streets. I'm Brad, I'm Face, I am BrotherMob. I'm Scarface. I gave my life to this game. I'm the realest who's ever done it. I am the truth. And this is my story.

PART ONE

SOUTHSIDE

MIND PLAYING TRICKS ON ME

Looking back, I think I just wanted the attention. I see that now. But back then, I felt like attention was the last thing I wanted.

I wouldn't have been able to tell you if it was any one specific thing that had pushed me to that point. I just know that I was mad. Mad and sad. And I know that I felt like no one wanted me. My daddy was dead and my mama didn't want me. I didn't really get along with my stepdad, and my grandma already had nine kids of her own, so there wasn't really a place for me at her house either. I just felt like I couldn't do shit right, and the only way I could get any attention was by fucking up. No one would come to watch me play football or check out my baseball games or any shit like that, but as soon as I popped some kid in the face or busted somebody's head open in class, everyone was there, telling me I was fucked up for what I'd done, trying to take away my privileges and shit like that. That was the attention I was getting: for being a fuck-up.

I was always being punished or outcast from the rest of the family because of some shit I had done, so every conversation at home was like, *Oh, you know they caught him with some weed, huh?* Or, *You know he was back there selling dope?* Or, *You know he got an F on his report card?* Or, *You know he hit that boy in the head with that baseball bat?* There was just always some kind of fucked-up shit going on with me, and by the time I was thirteen I was over it. I felt like everyone—my teachers, my classmates, the other parents in the neighborhood, my own family— was mad at me and on some fuck-you shit. So to me it was like, *Fuck you, too, then*. Shit. You don't have to tell me twice.

I would spend a lot of time alone. I'd go in my room at my mom's house and not come out for weeks, just trying to find me. And I didn't always like what I found. I was raised with the idea that I was born dying. That with every breath you take, you get closer to your last. It's something I've always known. So my mentality, even back then, was always, *What's the worst that could happen? That I could die or be killed? But I'm born dying, so death is inevitable. Why should I be scared of that?* So being alone just gave me something to really think about. And with shit going so wrong for me then and with me constantly feeling like everything was fucked and I couldn't do anything right, the conclusion I came to was that I might as well just get it over with. Fuck it.

I don't remember too much about that particular day, but I know I was ready for it to be done. I was ready to get up out this bitch, so I went in my mother's medicine cabinet and took all of her blood-pressure medication, as much as I could find. I woke up on the bathroom floor with the ambulance parked outside and the paramedics trying to get me up and out the door. They took me to the hospital and gave me this stuff, ipecac, to clean out my stomach. I spent the whole next day puking my guts out. It was disgusting. I thought *that* shit was going to kill me! It was like, *Damn, you brought me all the way here*

to do me in like this? You could have just left me on the floor and saved everyone a hell of a lot of trouble. I could have gone out easily. Shit.

But of course the ipecac didn't kill me. It probably saved my life.

Once they knew my stomach was clear of all of the pills and I wasn't going to die, they let me go. But then, the next day, my mama brought me back. I thought we were going for a follow-up, or a check-up or some shit, but then she just left me there, dropped me off on the mental-health floor of Houston International Hospital, and that became my life. See, it wasn't like that was the first time I'd tried to kill myself. I'd been trying to take my own life for years. You name it, I'd tried it. Slitting my wrists with a box cutter and bleeding out all over the bathroom floor, putting loaded guns to my head, all of that shit. If you'd asked me then, I'd have told you straight up: I was ready to go. But I never did it. I never cut myself deep enough or far enough away from my family to be left alone and die. I never pulled the trigger. I never went all the way. That's why I say that I think I really just wanted the attention. If you really want to go, the dying is the easy part. It's the living that's hard. That shit takes a lifetime. And it will test you every step of the way.

THE FOUNDATION

I come from a prominent family of musicians and artists. The music is in my blood.

My mama was a singer. Omazelle, named after my grandfather's girlfriend. How deep is that? She worked as an accountant at a hospital for over twenty years but she was a singer before all of that. At one point, she even had a group—the Watermelons—with her sister Marva, and her brother Wayne. My father was Blush Jordan, but I never knew him. He left when I was young and he was shot dead not too long after that. My stepdad, Willie, was more of a daddy to me than my father ever was. He worked in computers at an energy company, Digicon, and DJed on the side. He knew how to play the game. He was always on the hustle, drying weed in the closet and doing whatever he had to do to help us get by.

My cousin is Johnny Nash. His big record is "I Can See Clearly Now," and he recorded reggae in Jamaica and wrote with Bob Mar-

ley. My grandma, Rosemary, was a gospel singer. She was always singing in the house and she had an angelic voice. When she sang, it sounded like opera. And then there were my uncles. I had a lot of them, and they were always around fidgeting with something and making music. I spent a lot of time over at my grandma's house growing up, and when everybody would take smoke breaks, I would go fumble around and play the instruments. I was a product of that environment. I think the first language I learned to speak was music.

My grandfather was named Wayne. He wasn't a trained musician, but he taught himself guitar. He was one of the first black master plumbers in Texas, and if you ask anybody in my neighborhood, they'll tell you he was a bad motherfucker. He was tough as nails and strong as hell. He could hit you so hard it'd make you piss. He also always kept a gun and he would not hesitate to bring that pistol out and put it on your ass. My grandma don't take no shit either. She's Fifth Ward born and bred and hard as a sledgehammer. She's still alive as this book goes to print, and even today, at eighty-six, she still doesn't play.

We were like our own little colony over there in South Acres on the Southside of Houston, Texas. My mama was the second oldest of my grandparents' nine kids, and she was twenty-one when she had me. I was born on November 9, 1970, the firstborn grandson, which made me kind of like my grandma's last child—her tenth—because she raised me. My mama was more like a sister to me. I didn't see her as much as I saw my grandma. She would come pick me up from my grandma's house and take me to her house, but I was always bored over there. I preferred being at my grandma's house on Holloway. I had three aunts—Joey, Jean, and Marva—and I had five uncles— Eddie, Eric, Shine, Rodney, and Wayne. My uncles were always get-

ting into something. There was always something going on at Grandma's house and there was always something to learn.

When I first started showing interest in music, my aunt Marva turned me onto Steel Pulse and Andreas Vollenweider and Aunt Joey put me up on George Duke and Stanley Clark. But it was my uncles who taught me things. They could tell I was in love with it, even at an early age. My uncle Eddie bought me my first electric guitar when I turned eight. I learned how to play it upside down because my whole family is left-handed, including me. When my uncle finally started stringing it up right, I had to take lessons to learn how to play it the right way. Years later, I would get Uncle Eddie to play on my records. He's bad on the bass, and he always knew how to find the most incredible grooves.

My first love was rock. That's what they played at my grandma's house and that's what I grew up jamming—rock and soul. It was kind of like what you might think of as R&B today, but they didn't call it that back then. It was music for your soul. The first album I ever owned was Boston's *Boston*. My mama bought it for me. The second album I ever owned was the KISS *Dynasty* album. I was eight years old when it came out in the spring of 1979 and I wanted that album so badly I cried about it. Willie whipped my ass pretty good over it, too, because I gave my mama such a hard time. But I loved KISS. That was the band I most wanted to be like when I was a kid. I thought their whole shit was hard—with the face paint and everything. They were my childhood idols. I remember they toured that album that same year and I begged and begged to go to the show, but my parents wouldn't let me. Twenty years later, I got to see KISS three times in Los Angeles at the Great Western Forum. I called my mama and told her that it was well worth the wait.

The first concert I ever went to was Earth, Wind & Fire at the Miller

Outdoor Theatre. Chaka Khan was there, too. I was super young and I don't remember too much about it, but I know it was raining, we were close to the stage, and they jammed like a motherfucker. I saw Bootsy Collins, George Clinton, and Parliament not too long after that, and between those two shows, I knew I wanted to make music. I knew I wanted to be a performer.

ROCK BOX

When I was four years old, I told my grandfather that I was going to buy him a new house and a new boat and do a whole bunch of concerts for him. I had no idea what impact I'd have on the world, but I always imagined standing in front of people and playing my shit. There was nothing else that I wanted to do.

The first time I performed in front of a crowd was at the school talent show when I was in the sixth grade. I played guitar in a little garage band with some of my buddies from the neighborhood. We called ourselves High Energy and we played a lot of AC/DC, Black Sabbath, Iron Maiden, and shit like that. I don't think I had even heard any rap records until 1978 or 1979. Not that there were a ton of them floating around before then, but still. Even when I got an eight-track tape of Kurtis Blow's "Way Out West," I remember Willie coming home and tearing my ass up because I'd blown the speakers out on his system playing the song on guitar. I listened to

everything but I didn't care what anyone else was doing. I wanted to play rock and roll.

That all changed when I transferred into Woodson Middle School in the seventh grade. Woodson was an all-black school in my neighborhood. This was 1982–1983, and rap was really starting to take hold. I'm talking we were in it. It was *hip-hop*, and we were all about the four elements—breakdancing, graffiti, DJing, and rapping. That's all we talked about. That's damn near all we did. I remember being so into it that we'd take little plastic action figures and stick coins in their backs so we could make them do backspins on the lunch tables or in class. We were that down.

But it was Run-D.M.C. that really fucked us up. When they came out with *Run-D.M.C.*, we were gone. They were too hard. I fucked with that shit heavy. We all did. And then records like "Rock Box" and, later, Beastie Boys' "Fight for Your Right" and "No Sleep Till Brooklyn" made all of the rock shit I'd been doing and my whole background cool. And just like I'd always had a guitar, I'd always had two turntables and a microphone, so when rap became the thing, I was ready to go. I never really took to graffiti or breakdancing too tough, but I was about the music.

I started beatboxing and learning to DJ, and as soon as I started fucking with it, I wanted to be the best. I've always been competitive. It didn't matter what we were doing—if we were rocking out, I was going to be the coldest on guitar. If we were fighting, I was going to be the first one in and the last one out. When we started selling dope, I was going to sell the most or I was going to take it. One way or the other, I was always going to come out on top. That's just how it is with me. I don't know no quit. So whatever we had going on, I wanted to be the best at it. I had to be. Failure was not an option. I still don't know any other way.

So with music, that's exactly how it was. Once I started DJing, I was determined to be the best. I'm talking everything—the best blends, the best mixes, the best cuts, the best records, all of it. Shit, I even started rapping just so I could be a better DJ. You can blame Whodini's Grandmaster Dee for that. He was a DJ who could rap, and I just knew that I could outrap him. So I started rapping because I wanted to make sure that if I ever got into a battle with a DJ who could rap, I'd have all of my bases covered. I was determined that I wouldn't go down. Even if that motherfucker started rapping, I was going to douse his ass, no matter what. And shit, once I'd made that choice, there wasn't any question. I wasn't just going to be a DJ who could rap, I was going to be the best rapper at my school. I was going to be the coldest DJ/rapper you ever heard.

And I was, too. I would take time and write my rhymes and nobody could fuck with me. But to be honest, I was kind of cheating. I had a cousin in New York who was just a few years younger than me. She lived in Harlem and I'd get on the phone with her and get all kinds of records from her early on, before that shit got down to us. So while everybody was at school still kicking those hippity-hippity rhymes, I was already ahead of the game on some blast rap terrorist shit that was just becoming the sound of New York. I called myself DJ Akshen for All Krazy Shit Has Ended Now. I'm telling you, I was that cold, boy, even then.

MIND OF A LUNATIC

When they first checked me in on the mental-health floor at Houston International, I thought I was entering into some sort of outpatient treatment. I'd been depressed since I was young, and I'd just tried to kill myself—again. I figured they wanted me to talk to a doctor before they sent me back home, but that wasn't the case at all.

They diagnosed me with bipolar disorder and put me on lithium and Mellaril to try to even me out. (They pulled Mellaril off the market in the early 2000s, but sometimes I think I should still be on lithium today.) Then my mama left me in that motherfucker, and I spent the better part of the next two years at Houston International and Memorial Herman hospitals. I lived there, went to school there, went through therapy there, the whole shit—while supervised and medicated. I'd get out every once in a while and get to go home, but being in the hospital was my life for months at a time. Those years were tough. She did what she had to do. I didn't understand it, but it was what it was.

There wasn't anything glamorous about getting treatment at Hermann and HIH. It wasn't like we were at a special campus or some great facilities off next to a lake or near the beach or in the mountains or any shit like that. It was just being on a floor at the city hospital like any other floor, except I was surrounded by a bunch of people who were having some serious mental-health issues. It was mostly adolescents—from rebelling teens to heavy, heavy drug users—and it was all white kids, with a few black kids who thought they were white. I was probably the only nigga in there.

I remember there was one kid, John. He was kind of off, too, but he was always trying to be a badass or something. He was a little taller and bigger than everyone else, and he rubbed me the wrong way. You know those hotshot-ass white boys who try to act tough or some shit? He was one of those. Well, we all shared a room together—three men, three bunks—and one day he must have told on me for some shit or touched my radio or something. I don't know what it was that finally set me off, but I know this: whatever he did, I beat his motherfucking ass.

Now, of course that shit will get you into trouble. You can't just go around beating everybody's ass like that when you're in a supervised, controlled environment like a school, a hospital, or jail. And when you go crazy on someone in the hospital, it's not just you against him; it's you against the five or six motherfuckers that come to hold you down. But sometimes you've just got to do what you've got to do to make sure all of the motherfuckers in there with you know what it is, fuck what comes behind it. Like in that situation with John. After that fight, they shot me full of Thorazine and put me in an isolation area called the quiet room for a bit, but I ain't have another problem with any one of those kids that whole stretch. They knew what it was. And they knew what everyone on my block had already learned long ago: do not fuck with Brad because Brad will fuck you up.

But as much as I wasn't one to play with, eventually I realized that those motherfuckers weren't playing with that mental-health shit either. I learned a lot from that period in my life, but one of the biggest lessons was that no matter how hard you want it, you can't feel happy or relieved or secure or even sad just because somebody tells you that's how you're supposed to feel. It just doesn't work that way. At least not for me. I'm entitled to my own feelings and my own opinions, so if I want to be sad about some shit, I'm going to be sad about it, and there's no amount of therapy that's going to change that.

But that's not what they're looking for. They want to believe that their shit is working and that their way is the right way. It took me a minute to figure it out—and it got to the point where I couldn't even stand the idea of going to the quiet room—but once I saw what it was and how it worked, I knew I had to do whatever the fuck I had to do to get out of there or they would have me locked up for a long, long time.

So I did what I had to do. I shut up when they told me to shut up. I went where they said I had to go. I went through the therapy they prescribed. I stopped kicking motherfuckers' asses every time they did some little shit that set me off, and I bullshitted my way through the program and did everything I could to feel better about shit and get my ass up out of there as quickly as possible. It was either that or spend the rest of my life in the county psych ward, and that would have been that. There wouldn't have been a Scarface, there damn near wouldn't have been a Brad. I would have been just another black boy lost in the system, neglected, forgotten, and locked away by a society that never wanted me in the first place. Fuck that. I saw what it was, straightened up, played the game the way they wanted it to be played, and by the time I was fifteen, I was done. A year later, I signed my first record deal.

DOPE GAME, COCAINE

The first time I saw dope was probably 1982 or 1983. Some people I knew would get it and bring it home and cook it up. They'd have a butane burner and a beaker and they'd cook it up, pop the rock out of the beaker, and fire it up. See, back then it was cool. You could smoke crack and be functional. Shit, I knew guys who were smoking crack and still bringing home something like $50,000 a year, and this was back in the early eighties when that was good money.

I really believe that crack didn't get fucked up and start to destroy the black community until the government started the War on Drugs. That raised the stakes where everyone was risking a whole lot more getting involved with that shit, and then as time went on and niggas got cool with the Colombians and the Colombians started fronting niggas' work directly, that's when the game went haywire.

I got introduced to the game on the city bus. I had to take the 33 Post Oak bus to school, which was all the way across town. I hooked

up with a lot of different people on that ride, including a lot of guys who were a lot older than me. The bus route would take you from South Acres to Sharpstown Mall and then on to the high school that I'd started going to, Willowridge. Sharpstown Mall had a little recording studio in it and I started skipping school and hanging out there.

When I was fourteen, I finally moved out. I was in and out of Hermann and HIH and I still couldn't get along with my stepdad. I'd been living at my grandma's house when I was home from the hospital, but I'd gotten into a fight with one of my uncles so I couldn't live there anymore either. Looking back, I can't even remember what he did—probably stole some shit from me, or something like that—but I fucked him up pretty bad. But like I said, as much as the music was in my blood, my blood boiled, too. I was a fighting-ass motherfucker, and it didn't take much to get me going. And once I got going, I didn't give a damn whether you were friend, family, or foe, I would fuck you up. I'd hit you with a bat, shoot you with a pellet gun, beat you with a book, stick you with whatever there was to stick you with, I didn't give a fuck. If you crossed me, I was coming after you. And I wasn't going to let up. Even today, I'll tell you straight up: I hold a grudge like God.

But I got that from my grandfather, so when I beat my uncle's ass, it was my grandfather who came after me. I don't know if he was shooting at me or what, but I know I heard that gun go off, and where I'm from, when you hear that shit, you don't ask questions, you just start running. I know I wasn't about to stick around to see if he'd let off by accident.

But I told my uncle, *Next time I see you, I'm going to beat your motherfucking ass.* I wasn't trying to cross my grandfather because I knew he didn't play, but I needed my uncle to know that I didn't play either.

Not too long after I moved out, I dropped out of high school. I was

in the ninth grade and I was a smart kid, but I didn't really care about class. All I wanted to do was play football. I'd played running back and nose guard in middle school, and with all of my fighting coming up and just being raised by all my uncles, I was a problem because I was so fucking tough. I didn't give a fuck how big you were, I was down to take you on. But I couldn't keep my grades up and the school had a no-pass, no-play policy, so they kept me off the field. Needless to say, after a couple of semesters of that, I decided school without football wasn't for me and I stopped showing up.

Through hanging out at the studio, I met this guy John Okuribido. Everyone called him Bido and he was working to get into the music game, producing and doing a little managing. After we hooked up, we ended up being partners for years. Bido was managing a rapper named MC Casual, and Casual and I had become cool. After Bido heard me rap, he wanted to manage me, too, so I left the apartment I'd been staying in and moved into the same complex that Bido and Casual were living in. We weren't on that gangsta shit back then. We were still just trying to outrap each other. But when Casual got evicted, Bido moved into an apartment with his sister, and my mom helped me get a place not too far away. I was writing raps and Bido would tell me if they were any good. We started running around with a bunch of different people from around the way, and a lot of them were hustlers.

If you know anything about anything, you know how this goes. Me and Bido were out there hustling, trying to get some money together to make music and stay in sneakers and beepers. I was working at a movie theater and selling dope and mixtapes I'd made for people on the side. I wasn't rapping on the mixtapes, just recording mixes of popular records that I thought were fresh. I had a bit of a rep around the way as a good DJ and people would buy the tapes off of me for five

or ten dollars. There was no one watching what we were doing and we were lawless.

But I'd always been a hustler. I started selling weed when I was eight years old, stealing buds my stepdad had drying in the closet. I'd mix up what I stole with some parsley to stretch it out, then sell it to whoever was buying as either joints or a fat nick. Back then I was just doing it to hustle up a little extra candy money or to buy some baseball cards or whatever it was that I was into at the time. But by the time I was fifteen, I wasn't hustling for baseball cards anymore. I was selling dope for real.

JUST CALL ME SCARFACE

Bido started running with a guy from around the way named Lil Troy. This was before Lil Troy started Short Stop Records, and he wasn't focused on music then—he was just another guy from the Southside out here doing his thing, looking to get paid. Now, Troy had a partner he was running with and Bido and that dude became tight. I'm talking like brothers, they were so close. I learned a lot from him. He gave me some game, like how to make a spot bubble and how to dry a corner out. And if I had to get something, I would get the work from him.

I must have been about sixteen when I first saw somebody break down a ki. I remember walking into my buddy's house and he and his friends had it broken down all over the table and they were weighing it up. I'd never seen some shit like that. The whole house smelled like Sheetrock. I didn't know it then, but that's what that shit smells like—Sheetrock. Once you know that smell, you'll never miss it. These were some older friends of mine, and once my buddy had that thing broken

down, he put an ounce of powder in a bag, weighed it up, and threw it to me. I'd been selling rocks for a while, but this was my first opportunity to really get it in.

But I didn't know anything about cooking dope, so I took it to a guy I knew. We took it over to this dude's house where we used to hang, and I got another dude to cook that motherfucker up right there. When he was done, I took it back to my apartment rocked up and cut it down into bags. That's where it all started for me. That's when I really started my career selling dope.

Back then, the street value for an ounce of coke was $500, and we took that ounce and cut $2,200 of rocks out of it. Crack was still pretty new and we were basically responsible for the whole Southside getting on that shit. Then when Houston got tapped out, we just took the work out of town where we'd have less competition. It was really just the big boys playing in the smaller towns and they were so busy selling weight, they weren't going to come back down to the ground level. That gave us room to set up shop and move the rocks, and that's exactly what we did. Some of my boys didn't really want me around too tough because I was a fucking fool, and it didn't take much for me to set it off, so I'd have someone drive me out of town with ounces and ounces and ounces of rocked-up dope, and I would work that shit myself.

We cleared $1,700 off of that first ounce, and then we went back and bought two ounces and we worked our way up, moving in and out of these small towns outside of Houston putting in work. This was before the police were completely hip to what was going on, so it was easier to move around. We'd hide the dope inside tennis balls and tennis-racket handles and put them in a gym bag in the backseat. If the cops pulled you over and wanted to know what was up, they wouldn't even think to check that shit out back then. They'd just let you go.

Two ounces got us three ounces and then three ounces got us four.

As we got bigger, we started making our rocks bigger—I'm talking white, flakey dope. Instead of cutting $2,200 out of an ounce, we'd cut $900. Doing it that way gave us these huge rocks—twenties the size of a quarter—and motherfuckers would be passing through our neighborhood and knocking on our door all day long. Sometimes I think we were responsible for bringing crack to those communities outside of Houston because they were so dry until we touched down.

I never cooked my dope because every time I cooked it, I would fuck it up. My shit would be white with lots of holes in it. And it would always be wet. But that didn't stop me. I had professional cookers who could stretch an ounce out to a goddamn ki, damn near. And we were getting it in. Four ounces got us five, five ounces got us six. Six got us seven, then eight ounces, then nine. We were working our way up.

We would cut that shit up into rocks or slabs, and whatever was left over we would smoke in a primo joint or on a soda can or sell it as a two-dollar or five-dollar shake pack. Shit, sometimes the five-dollar shake pack was even bigger than the five-dollar rock. And we didn't even have to cook our own shit. Over on this street, Phlox, the crews were serving up rocks so big they didn't even look real. We called them flippers. You could buy $100 worth of rocks on Phlox and go sell them for three or four times the dough.

I've gotta laugh sometimes when I listen to some of my old records because I was putting so much personal shit in there. When I rapped *I was rocking up eight balls, and mo'ing the scrape/Kept a thousand in my pocket, twenty more in the safe* on "On My Grind," I wasn't just saying that shit because it sounded cool. It was what it was.

WE HAD ABOUT SIX OR SEVEN NIGGAS IN THE CREW, BUT IF WE needed some muscle, we had older cats—the guys we were getting our work from—that were down with us, too. The little man was feeding

the big man, and if we ever found ourselves in the corner, we could always rely on the big man to step in. As for us, we weren't thinking about trying to build an empire. To be honest, we didn't know there were millions to be made in the dope game. At least I know I didn't. We just wanted to look like we were making that kind of money.

We were cool making $2,000 to $3,000 a week. We weren't tripping. It wasn't BMF money—we weren't buying helicopters or none of that shit—but as long as we were driving cars with some tight-ass rims and a system, the Jordans on our feet were fresh, the beeper bills were paid, the apartment was fly (I'm talking waterbeds, big screen TVs, and all of that shit), and we had a couple of thousand in our pockets, some bitches on our arms, and some gold around our necks, we were good. And we were recording the whole time. There were guys around us that didn't want to get into music—they were too far gone, with Jags and Benzes and houses and all of that shit, just from the dope game—but we still wanted to do music. Considering that we were fifteen, sixteen years old, we were making a killing.

But it was a dirty game. I don't have a lot of regrets, but I hate a lot of shit that I did then. I sold dope to my family and my friends and friends of friends. I fucked dope fiends' wives, I traded rocks for cars—you name it, I did it. When people would come to our corners and we didn't want them there, we'd shoot that whole motherfucker up, just to dry it out. You shoot up a street corner and those police would be out there quick, and then nobody could work. And we'd just wait that shit out. As soon as the cops were gone, we'd be right back out there, pushing work. Some other crew shows up and tries to set up shop? We'd just shoot that motherfucker up again.

But the rule of thumb was that you never let your left hand know what your right hand was doing. If you were going to burglarize a house or steal a car or rob a nigga that had some work, you did that shit by

yourself because if the right hand gets caught, then the left hand can't tell shit because he wasn't around the right hand in the first place.

Without getting too into it, let's just say that a lot of dope houses got broken into and a lot of shit got stolen out of a lot of safes. And I know for a fact that a motherfucker can go knock on somebody's door and damn near spend the night in that house and kill everybody in there and then get up in the wee hours of the morning and walk out of there like nothing ever happened. Not me, but I know some people like that, you feel me? And that's what it was. We didn't give a fuck about death or jail. We knew that shit was inevitable. From 1986 to 1990 or so, we went hard.

We got up to a half a ki and then we called it quits. I thank God that I'm still alive and a free man because we definitely took some penitentiary chances to make a dollar. When they changed the crack laws in the late eighties, people were getting popped left and right. I look at all of the people that I grew up with—I'm talking my really, really close friends and all the homeboys I came up with—and they're all either locked up, just now getting out after serving twenty years, or dead. I'm not exaggerating. Everybody. And that could have been me.

I remember one day when I was sixteen. It must have been the first of the month. We had about $160 worth of rocks left and this undercover motherfucker walked into the house that we were working out of acting like he wanted to buy the rest of the dope. And you know, we were with it. But then, just as we're going to get him straightened out, he pulls out his badge and his gun.

Is that all you've got left?

Yeah, man, that's it, we told him.

He took the work into the bathroom and we heard him fucking around in there, flushing the toilet and shit like he's getting rid of all of it.

When he comes out, he says, *I just want to let you all know you're running a fucked-up business here. The next time I catch you fucking up, I'm going to put your ass under the jail, all right?*

Man, we were madder than a motherfucker when he left! We were convinced he was bullshitting us, figuring he was either some dope fiend or a crooked-ass cop (or both) who had just robbed us. So we re-upped and bought another ounce, planning to cut that bitch up the very next day. When we went to pick it up, we got it in two halves, so I rolled them up real tight and stuck one of the halves between my legs under one side of my nuts and the other half under the other side and pulled my drawers up. And do you know that same motherfucker rolled up behind us and pulled us over as we were riding out?

He got us out of the car and I'm shaking like a motherfucker because I had that dope on me. He searched us, too, but he didn't find it.

Why are you shaking so hard? he asks me.

Shit, it's cold out here! I say.

I told that motherfucker that I'd learned my lesson the first time and he let us go.

Like I said, it didn't miss me because I was a pussy or I wasn't in it; the only reason it missed me is because once I saw a way for me to get the fuck out of the game, I got the fuck out.

MONEY AND THE POWER

I knew who Lil J was before I met him. Or put it this way: I had heard the name. We all had. His real name was James Smith, but everybody called him Lil J, and he was a hero of Houston's Northside. But on the Southside—my side—Smitty was the man. Smitty was a buddy of mine I had met around the way, just through the circles I was running in, and he had a huge impact on my life. He used to come and pick me up in his white Benz, with the blue leather interior, when I was still living at my grandma's house. That shit was dope! I had never seen anything like it because we were so hood. But Smitty was doing it. He was big time. He'd always break me off with hundred-dollar bills and take me partying and shit. I remember he even bought me some Troops once. He ended up getting killed, though. Shot through the mouth with a Carbon 15, but that's another story.

I actually thought Bushwick Bill was Lil J when I first met him.

See, back then James had a couple of businesses on the Northside—the used-car lot that inspired the Rap-A-Lot name, and a big nightclub called the Rhinestone Wrangler. We didn't hang out at the Rhinestone too tough because it was on the other side of town and there was a lot of mistrust between the Northside and the Southside even then, but the Rhinestone Wrangler was where it was at. All of the big acts that came through town would play there—De La Soul, Slick Rick, Dana Dane. If you wanted to see a big hip-hop act in Houston in the eighties, you had to go to the Rhinestone.

Well, so I'm at the Rhinestone one night and I see this little dude, I'm talking not even four feet tall, sitting at the bar chatting up some chick and I hear him tell her he's Lil J. So I figure, well, damn, that probably is Lil J. Of course, it didn't take me too long to find out that wasn't James Smith, that was Bushwick Bill. Bill didn't own the Rhinestone, he worked there as a busboy. And while he's definitely a small dude, he just as sure ain't no Lil J. Not by a long shot.

I didn't meet the real Lil J until later, after I recorded the song "Scarface" for Lil Troy and Short Stop. Bido and I had been hustling, trying to figure out how to break into the music game. In 1986, we hooked up with a little local outfit, H-Town Records, to lay down a song I'd done called "Big Time." I recorded it under the name DJ Akshen and we were excited. Finally, we were going to get my music out there and start to make some noise! But then Jesse, who ran H-Town, came back from the record plant with the song on these little 45s. Man, Bido was mad as hell, screaming on Jesse like, *You can't put our shit out on a 45! What are we going to look like coming out on a 45? That's some rock shit, man. What's wrong with you?*

Well, shit, it wasn't too long after that that Bido suggested we should go ahead and do a couple of records with Troy and see how they turned out. I was with it. Troy was just starting to try to get Short

Stop off the ground and anything to get my shit out there sounded like a good plan to me. I was still recording as DJ Akshen, but I had written a song called "Scarface," based on all of the shit that we'd been doing in the streets. I actually hadn't even seen the movie when I wrote the song, but when the people in the hood would hear about all of the crazy, ruthless shit we'd been up to, they'd say shit like, *I can't believe y'all did that shit. That shit's straight out of the* Scarface *movie.* So I just ran with that and made the line "just call me Scarface" the hook. I already knew we weren't to be fucked with. Al Pacino just gave me a character everyone knew to build on and really let it be known.

Once we had the record, I took it to Steve Fournier. Steve was this real cool white dude from Houston who DJed at the Rhinestone and had started this thing called the Rap Pool of America, which was this giant record pool he'd created to hook up DJs around the country with the hottest hip-hop records as soon as they came out. Thank God for Steve Fournier. He took the record to Rap-A-Lot and played it for James. I'd actually tried to get on Rap-A-Lot a few months before we cut the song, but they weren't into the records I'd played for them.

They told me, straight up, *This is not what we're looking for.*

But with "Scarface," it was different. J was into that gangsta shit, and he started coming down to the Southside, combing the streets looking for me. It was only a matter of time before he found us.

Me and Bido had a little town house, and the day J rolled through, he pulled up in a white black-top 560 Benz convertible. He came in there looking like Slick Rick, but instead of gold, he was draped in diamonds. He was iced out before everyone was iced out, with a big diamond chain and one big diamond-encrusted Rolex. That motherfucker was twenty-two years old and he was shining. As soon as you saw him, you could tell he had it all—the cribs, the bitches, the cars. I was sixteen when I met him and he was already sitting on thirty acres

with horses and a crib with an elevator in it and marble floors and double doors everywhere. He was so far ahead of us, even then. From that day on, I was sold. That was my role model. I wanted to do whatever it took to get that. I wanted to be like J.

I don't think J knew I had the work in that town house, but if he did, he didn't say shit. He didn't want to talk dope. He wanted to talk music. See, J was smart at a young age. He came over to the Southside and did something that nobody else was willing to do—he went and got deals and got money and got acts.

If you're not from Houston, it's hard to really explain just how divided the city was then. Nobody I grew up with was cool with Northside niggas like that. I don't know where it came from, but we despised everybody who wasn't from our side of town—niggas, bitches, everybody. To us, the Northside was a completely different culture, almost like being from a completely different city. And the niggas on the Northside saw it the same way.

They wanted to make their cars go fast and we wanted to ride slow and pop doors with elbows and vogues and candy paint. They wore their hair in braids, we rocked fades. It was just different. Even right now, there's still distrust. I think a lot of shit just went down between the Northside and the Southside over the years and we all lost a lot of friends. It's like Crips and Bloods in L.A., but we don't have colors. So for J to be in that town house talking to us about joining up and making a real play? That shit was unheard of. But J had a vision, and what he saw was light-years ahead of what anyone else was thinking at the time.

As for me? I just wanted to rap. I already felt like shit was kind of fucked up for me at Short Stop. Around the same time that we recorded "Scarface," Short Stop had recorded another song with another rapper Bido had been working with, Lord 3-2. He would go on to be

known as Mr. 3-2 and record with Big Mike as the Convicts, but back then we were just two kids trying to get on. The streets were going crazy around the "Scarface" record, but Troy didn't like it as much as he liked 3-2's song, which kind of sounded like an early version of the D.O.C.'s "It's Funky Enough."

When Short Stop got behind 3-2 it put a sour taste in my mouth. I was never interested in being considered second best, so I was trying to get out of the way. Bido and I were still recording and James would come by every now and then to hear what we were putting down, and eventually J and Bido talked and J went to talk to Troy. Of course, after J started showing interest in me, Troy and Short Stop didn't want to let me go, but I had never signed anything with Short Stop. They could try to lay whatever claim they wanted to, but in the end there wasn't anything they could do to stop me from making a move. I don't know what J and Troy worked out in the end, but whatever it was, I wasn't mad at it.

On August 18, 1987, I signed to Rap-A-Lot Records as a solo artist. It was my first record contract. I was sixteen years old.

PART TWO

WE CAN'T
BE STOPPED

CHAPTER 8

MAKING TROUBLE

There was already a group called Ghetto Boys on Rap-A-Lot before I joined the label. They'd put out a single called "Car Freaks," which was one of the really early records to actually come out of Houston. Everything else was coming from New York, and the stuff that was coming out of Houston sounded so far behind it was like Cracker Jack rap—just super-simple rhymes not saying shit that couldn't have been printed on the back of a pack of some kiddie snacks. "Car Freaks" wasn't crazy, but it gave J something to build on.

I don't know what happened between "Car Freaks" and the Ghetto Boys' first album, *Making Trouble*. I wasn't there. But the group that ended up recording *Making Trouble*, was a local rapper named Sire Juke Box and two guys who'd moved to Houston from New Jersey—a DJ/producer who went by the name DJ Ready Red and an MC friend of his who rapped as Prince Johnny C. Somewhere along the way, they decided to add a guy from Brooklyn who was small as shit. At first, he

went by the name Little Billy, but by the time I met him at the Rhinestone, he'd already changed his name to Bushwick Bill.

J broke new ground when he put out *Making Trouble* in 1988. That and Raheem's solo debut *The Vigilante*, released the same year, really put Rap-A-Lot on the map. Raheem was dope. He and K-Rino were really two of the only guys to come out of Houston back in the early, early days that were really skilled and actually sounded like something. Shit, Raheem's still probably one of the baddest motherfuckers I've ever heard. For the first time, you could finally tell that people from walks of life closer to the average Houston nigga's experience were making music. And while J had hooked up with A&M to push *The Vigilante*, he distributed *Making Trouble* all on his own, making Rap-A-Lot one of the first black-owned and -operated rap labels in the South to really make some noise. But *Making Trouble* was just the beginning.

The first time I met Ready Red was when J took me to Red's house to battle J's little brother to see who was going to be in the Ghetto Boys. I don't know what happened with Johnny C because I wasn't a part of the picture when he left, but with Johnny out, there was a spot to fill in the group. I didn't know it was a battle when I walked in—I didn't find that out until later. All I know is that I went in there and rapped a few verses, then J's brother, who went by Sir Rap-A-Lot before changing his name to K-9 rapped a few verses, and that was it. Nobody said anything, and then a couple of days later, K-9 wasn't a Ghetto Boy anymore and I was in and we were headed out to the ranch that J had outside of town to record. The album we made out there was *Grip It! On That Other Level*.

Even though I'd originally come in as a solo artist, J was determined to build on the success of *Making Trouble* and make the group work. He'd already signed the 1985 Golden Gloves state champ Willie D after hearing about him tearing fools down at the Rap Attack MC battles

they used to have every Sunday at the Rhinestone. (Willie won that thing thirteen weeks straight or some shit like that. He was a bad motherfucker.) And then he had come over to the Southside and picked me up after I lit the city up with "Scarface." I guess he thought if he could take Willie and me, plus Bushwick and Ready Red, he might really have something, so he put us together, changed the spelling, and we became the new Geto Boys. Well, shit, he was right about that.

I don't know if the other guys knew each other before we all went out to the ranch, but outside of meeting Ready Red that night at his house, I didn't know anybody. James didn't care. He left us out there in the middle of fucking nowhere. Me and Willie D were supposed to write and Ready Red was going to make the beats. Every once in a while, James would come through and break us off with a few hundreds, to the point where we used to say he must have been printing them up himself. We'd go record shopping and buy a whole bunch of shit and then he'd take us back out to the ranch and we'd be stuck. There was a drum machine, a four-track, a microphone and some records, and that was it. There wasn't shit to do but make music. James would come through every now and then to listen to all of the music we were working on and then we wouldn't see him for another three or four days. He did have a VCR, though, and I finally got to see *Scarface*.

I was fresh out the dope game when I signed to Rap-A-Lot, but when it came to making music, I saw myself as an MC. I just wanted to outrap a motherfucker. But while James was looking for skill, simply outrapping motherfuckers wasn't what James had in mind. J was traveling all over the country and seeing niggas just like us everywhere. We were all still kids, and we'd never left the hood, but James knew that the whole world was a ghetto before we'd even made our first song. He had a vision. He wanted us to touch all of

those people that he knew were there, but weren't being spoken to and needed a voice.

We had no idea that there was a whole country that was just like us, and that niggas in D.C. and New York and Chicago and L.A. were dealing with the same shit that we were dealing with in Houston. We didn't know that they had family members on drugs, just like we did, or that they were raised in single-parent homes, just like us, or that their grandmas got up just like ours and put that big block of government cheese on the bottom of the oven, melted it down, and made pizza, just like ours. We didn't know that everyone was struggling and that everyone was fucked by being black in America, and that we weren't alone. But J knew that from jump, and he knew that that's what he wanted to hear on record. Shit like "Assassins" on *Making Trouble*, but more real, more direct, and more to the point. He wanted us to let niggas know that we lived just like they lived, that we understood the story and that we were all part of the same struggle. That was the music that he wanted to hear us make.

James was a big factor in those early Geto Boys sessions. He was the strength behind the label, no question about it, and his input, especially back then, was invaluable. We'd start out writing a record and then he'd come in and say things like, *Don't get me wrong, it's strong, but it'd be a lot stronger if you talked about this*, and then he'd feed us different scenarios and we'd have to go do our research on what had happened, chop it up, and write a verse about that. All of that early, controversial shit about abortion, homosexuality, snitches, drugs, whores, niggas crying and dying over bitches—it all came from him. We were kids when we were recording that album, listening to him and learning.

It was J who really gave me the green light to talk that street shit. J and Willie D. Willie was already a shit-talking motherfucker. I'd seen

Willie around town, but I didn't really know him until we were out on the ranch. It didn't take long to realize that he really didn't give a fuck. To hear him get on the mic and really talk that street shit encouraged me to get in the booth and talk my own shit. And then when Willie heard me go, he was like, *Oh, nigga, you can rap your ass off! Go 'head!* He was a little older than me, too, and I was a Willie D fan—I still am—so hearing that from him was powerful.

Even still, I was nervous to really let loose. I can't speak for the rest of the group, but I was still fucking around in the streets. I was working rocks and I knew that shit firsthand, but putting it on record felt like it would draw too much attention, almost like ratting myself out or some shit. But eventually J was like, *Nigga, you ain't fucking around no more, talk about that shit.*

If J was dealing and dabbling in drugs back then, we never knew. I know the one time we asked him to front us some work he quickly set us straight.

Man, I don't fuck around with that shit, he said.

He wasn't pissed that we asked, it just was what it was. The way he saw it, if you were going to fuck with him, you were going to have to be all the way clean or it wouldn't work. He wasn't playing with that shit. I think after that car got stopped in '88 with seventy-six ki's in it and dealer plates that came off of his used car lot, he didn't want anyone around him that was fucking around. So we got an ultimatum. James told us straight up: *You're either going to do the one or the other, but you can't do both.*

And shit, by the time we were on tour in early '92, we'd cut it out. Or at least I know I had. I don't think James knew what I was doing—or if he did, I'm not sure he knew I was putting in that kind of work—but him telling us, *Either you're going to rap or you're going to sell dope,* changed the whole music scene in Houston. I walked away from the streets and decided to rap. It was on.

TRIGGA HAPPY NIGGAS

Grip It! On That Other Level came out on March 12, 1989, and we started to get a little buzz around the South and Midwest. We weren't really seeing any money off the album—at least none of us in the group were—but motherfuckers were getting hip to niggas kicking that street shit and we were right there in the mix. Ice-T had really set the stage with his first album, *Rhyme Pays*, and then the song "Colors" from the film of the same name. "Colors" was hard. Ice wasn't rapping super tough on that record, but he was talking that real-life shit that we were all living. It was real in the field and Ice was letting you know. Then N.W.A dropped *Straight Outta Compton* in the fall of '88, and that's what really fucked niggas up. Before that, the only hip-hop that really mattered was coming out of New York. Ice had his thing going in L.A. and Too $hort was starting to pop in the Bay, but *Straight Outta Compton* changed the game. The beats were big and mean as a motherfucker and the rhymes were tight enough to hang with anything

coming out of the East Coast. N.W.A really kicked the door down and opened the whole country up, and we burst right through that bitch ready to stake our claim. It was just like James said—the whole world was a ghetto. *Grip It!* sold like crazy—five hundred thousand copies independent. And that's when Rick Rubin called.

Now, you've got to understand, I didn't know shit about shit at the time. I was still just a kid. In New York and L.A., Rick Rubin was already a legend. Working with Russell Simmons, he'd taken Def Jam, the label he'd founded in his college dorm, and turned it into the world's first hip-hop powerhouse. All of the shit that I was fucking with—Run-D.M.C., the Beastie Boys, L.L. Cool J, Public Enemy—it had all come through him. Like me, he had a love for rock and rap and he'd taken those two passions, mixed 'em up, and made superstars. Shit, by the time he was twenty-six, Geffen had stepped up to back him on his new label, Def American. And he wanted the Geto Boys to be the first rap group he'd signed since branching out on his own. But I didn't know any of that. All I knew was that there wasn't any money for me in rap back then. No matter how many records we sold, the music wasn't bringing in the dough.

Whatever the particulars were of the deal that James, Rick, and David Geffen worked out, I saw $4,000 off of it. That's it. We did a couple of new songs, and James and Rick took those and put them with some of the earlier records we'd done for *Grip It!* and made *The Geto Boys* album. I took the $4,000 I'd made and bought nine ounces at a $500 discount because my partner cut me some slack. I wasn't concerned about the music. As long as I had enough money to re-up with my Southside niggas, I was good. The Geto Boys had a hit album in stores and I was still running back and forth out of town filling five or six houses at a time with work. That was the money I was making. I don't know what anybody else at the label was doing, but I wasn't

taking home any money from rapping and I fully intended to make my money on the streets with the people I grew up with. That's what I knew. It wasn't until we went on tour with Public Enemy in 1992 that I finally knew I was out of the game. I remember I got something like $50,000 for that tour, and I was like, *That's it for me. I will never fuck with that shit ever again in my life.* And that was it. I was done.

Of course, things didn't really work out at Geffen after all. Right before *The Geto Boys* was about to be released, Geffen backed out, saying they refused to distribute the album because the content was too offensive. They'd already had problems with their regular manufacturer—some Indiana company that refused to press up the album because it offended them or some shit—but then the label pulled out completely. Can you believe this shit? This was coming from the same motherfuckers who were distributing Def American albums by Andrew Dice Clay and Slayer, and making a killing off of Guns N' Roses. Andrew Dice Clay was like the scariest shit in America at the time, but somehow the Geto Boys were too extreme? Guns N' Roses were one of the biggest rock groups in the world—I'm talking sold-out tours, videos on MTV, merchandise, the whole shit. Axl Rose was running around singing about all of the heroin and easy pussy he was getting, chasing death in the alleys of Los Angeles, and somehow that was okay, but those same stories told from our perspective were somehow a problem. Man, fuck that shit for real. We were just a rap group from Houston with some street records looking for a big break. If you ask me, Geffen just didn't want to see a bunch of niggas make some real money. When you think about all of the shit that we went through just trying to find a place to put our music, it's hard not to see that shit as what I really think it was: active discrimination. We were entertainers just like the rest of them. The album didn't come with a fucking gun and an eight ball.

Def American ended up working something out with Warner, and in late 1990 *The Geto Boys* album finally arrived in stores. (The crazy shit was that Warner owned Geffen, so in the end the labels making the money were all in the same gang—it was all a bunch of pussy-ass posturing, if you ask me.) But that shit with Geffen was just the beginning of a cloud of controversy that would follow us around for the rest of the nineties. It started to seem like every time I turned around we were caught up in some bullshit—either in the media or in the courts or with cops or the government. It was always something.

Shit, less than six months after *The Geto Boys* dropped, they somehow had us tied up in a murder that we had absolutely nothing to do with. We weren't even in the state! This shit was so crazy, I couldn't even begin to try to follow it. All I know is some kids were at a party in some small town in Kansas and I guess they'd been listening to *The Geto Boys* or *Grip It!*—one of the two. They'd had some drinks, smoked some weed, and then on their way home, they decided to shoot some dude in the head, I guess for no reason, I have no fucking idea. But when they got to court, they for damn sure decided they had a reason—the Geto Boys made them do it! They said they were "temporarily hypnotized" by the song "Trigga Happy Nigga."

When I heard that, I had to give it up to the lawyer. That motherfucker was brilliant. His job was to defend his clients no matter what, and since it sounds like there wasn't much of a defense, he decided to try to pin that shit on us. Tipper Gore and the Parents Music Resource Center had been out there making a lot of noise about harmful lyrics and shit like that, 2 Live Crew was under the gun in Florida, and our little Geffen fiasco had put us out there in a negative light, so I guess he figured, Might as well give it a shot. Maybe he had seen it in some case law somewhere or something. Either way, on some level you kind of had to respect the balls of it. To stand up in court and say,

Yes, my clients pulled the trigger, but the records made them do it!—ain't that some shit?

But it didn't stop there. A year later, I got caught up in the same shit all over again when a kid from around my way killed a Texas state trooper after being pulled over on the way from Houston to Austin. He didn't say he was "hypnotized" like the kids in Kansas, but he did try to say that years of listening to records by me and by Tupac had somehow contributed to him deciding to pull the trigger that night. Of course that didn't come up in the confession. It was only after the case went to trial that the music somehow became the motive. The lawyers in that case even threatened to subpoena me over that bullshit, but the judge denied the request.

In both cases, the jury didn't buy it, and the kid in Texas actually ended up getting the death penalty behind it. That shit is fucked to me because I know firsthand how the cops can get on you out here when you're a young black man, especially in the South where the good ol' boy and cowboy mentalities are the law of the land.

I'll always remember when I was seven or eight years old and me and some friends were riding around the neighborhood on our bikes when we came across a crime scene. One of the cops waved us over to talk to us about what we'd been up to, and when we got closer he said, *Where have you boys been? I smell watermelon. You boys been eating watermelon?* And we didn't get it. We hadn't had any watermelon that day or maybe even that week—we'd just been riding our bikes. It wasn't until I was older that I realized what he meant and that he'd been making some fucked-up, racist-ass joke directed at us. At kids!

That's the culture we grew up in and around, and there ain't shit sweet about it. I've always known why we were making the music we were making, just like I know how a lifetime of subtle and blatant racism and oppression can make you want to reach for your pistol

and either shoot the oppressor or shoot yourself. When you live in a society that repeatedly tells you that it values a white person's life, safety, values, and lifestyle more than your own, and you get reminders of it every day and at every turn—whether it's the Michael Brown case or just talking to a friend or family member about some fucked-up shit they just went through while living their life—it's very easy to come to the conclusion that the best solution to all of this shit is violence.

I know for me, my grandmother's mother put the fear of white power in my grandma and then she put the idea of *Stay out of these people's way* in my mom. But my mama grew up through the era of desegregation. She lived through the separate drinking fountains and separate schools and restaurants that she couldn't eat in just because she was black, and she saw all of that change with the marches and protests and the rise of the Black Panthers and all of that shit. By the time I was growing up, she wasn't having any of that *Sit down, get out of the way, say yessir and no sir* shit. Her attitude was *Fuck that!* She raised me to think, *He's a man just like you, and if that motherfucker hits you, you better make sure you hit him way harder.* She put that same *Fuck that!* attitude in me.

And that's what it was about for me. That's what it was about for all of us—everyone at Rap-A-Lot, all of the Geto Boys, all of the MCs making music at that time, shit, hip-hop culture as a whole. It was about carving out a space and a success that couldn't be stopped or controlled by some crooked-ass cops or the state or corporate America or anything that had anything to do with the traditional white establishment. We knew we couldn't win the race. It wasn't designed for us to win, not no way, not no how, so it didn't even make sense for us to try to run in it. Instead we looked for ways around it, and that's where the dope dealing and the music came in. It was all outside of the

system. Working with James, who was totally independent, was just another way to make sure that we couldn't be controlled. And I really think it made those motherfuckers crazy to see us winning like that. They couldn't stand it, and that's why they stayed on our ass.

Still, I wasn't walking on that bridge with those kids in Kansas that night and I for damn sure wasn't sitting next to that kid in Texas and telling him to pull the trigger and kill that cop. And like I said on "Hand of the Dead Body," neither was Ganksta N-I-P, Spice-1, or Pac. Those kids made those choices all on their own.

Now, I don't know about you, but no album has ever made me do some shit I didn't already want to do, and I can't imagine that my music—or anyone else's—could control the mind of any man, woman, or child, especially one who was otherwise mentally healthy. I've been listening to Manowar, Iron Maiden, and Judas Priest since I was young, but you don't see me running around out here biting the heads off of bats. And I get it. Kids are kids and kids are impressionable. Shit, when I was young and playing football, I'd run over motherfuckers in the neighborhood yelling, *I'm Earl Campbell! I'm Earl Campbell!* because he was my favorite player and I'd seen him run over motherfuckers on TV. No one wants to believe that their kid is a monster, but, real talk, the only piece of entertainment that's ever really influenced me to take action is some porno, and that's just giving me ideas on some shit I might like to try.

When you take that pistol, you aim, and you shoot—that's a real fucking personal experience, and if you're doing it just because you heard it on a rap song or you saw it in a movie, then I can't help you with that. You've got some real shit to work out and that's not my responsibility. For real.

But no matter what they tried to do to us—no matter what kind of shit they tried to throw at us or what kind of shit they tried to pull

us into that didn't have a damn thing to do with us—the controversy only fanned the flames. Every time they talked about us on the news, more people heard our name, and the more people wanted to hear our music and come to our shows, the more the people in power hated us for it, and that just made the fans love us even more. America's always loved a good outlaw, and we were lawless.

I'M BLACK

As badly as the country wanted to make everything a *Cosby Show* moment, the reality for the majority of black America was really more *Boyz n the Hood*. And people wanted to hear that shit. Even today I think that's still true, for the most part. But when we came on the scene and as things continued to develop in hip-hop, it became less and less about people trying to outrap each other and much more about delivering the truth and getting the word out about what was really going on in the streets of America, not just what America wanted you to see. And it was that hunger for information—after being starved of it for so long—that really led to a great run for everybody who was making the kind of music that we were making. Because we were all conversing with each other, and letting everyone know that the shit that they were dealing with in, say, Chicago or L.A. was the same kind of shit we were dealing with in Houston and the same kind of shit niggas were dealing with in D.C. or New Orleans or Baltimore

or Memphis. And it was just that knowledge and that familiarity that made the shit so compelling. Because you can be out here and start to really think that you're the only ones getting fucked or the only ones going through some crazy shit on the block, but then you hear these records and it's just like, *Oh, shit, I was just listening to a motherfucker from Cleveland and they're going through the same shit we are right here.* And that's powerful. It's powerful and empowering to know that you're not alone even when your back is against the wall and the shit is just straight horrific, knowing that it ain't just you or your crew or your block or your town or your police department or whatever it is—that's some powerful shit.

And it ain't like I'm just making that shit up. You can see it in the sales and the way the music just exploded. Because once the records of niggas telling their side of the story started getting around, that's when we realized that the whole world was a ghetto. When we got a new album from Tupac or a new album from MC Breed, it was like, *No shit? The police are fucking with you in Flint, too?* Or, *Niggas is selling dope and getting shot in Oakland, too? That's the same shit that's going on in North Carolina, which is the same shit that's going on in Port Arthur, which is the same shit that's going on in Miami . . .* and that's why the shit was so popular. Niggas really wanted to hear what was going on in everybody else's world, and that was a great thing.

So there we were, delivering the word that niggas wanted to hear, and it was fresh and straight off the block—raw, uncut, and unadulterated. When it first started out, the system didn't want anything to do with us. They didn't know *how* to do anything with us. We were doing our own thing. And that was a threat, and that's why they tried to shut us down. I really think that's why rap was always getting dragged into congressional hearings and shit like that, because niggas were making money—legally—and lots of it, and the American system hadn't

figured out how to take its cut. Of course, once they figured that shit out, all of that political pressure stopped.

They always wanted to say that we were glorifying violence or the street life or drug dealing or sex or whatever it was. Anything that made them uncomfortable, we were "glorifying" it. I never understood that. We weren't glorifying shit—it was just there. If I say I get a lot of pussy, you could say that's glorifying fucking, but if you ask me, I'm just telling you how it is: I get a lot of pussy. To me, that's just speaking the truth.

Nobody was trying to glorify a goddamn thing. It was just about being as real as you could be. It was what it was at that time. It's still like that today. We have a problem in this country with telling the truth about what's really going on, especially when it comes to the history and the day-to-day realities faced by the black population. It's always skewed or distorted or ignored. Sometimes I can't tell which is worse. Would I rather they ignored the death of Michael Brown, or would I rather they shoot him dead and then try to paint him like a criminal?

So I really think that a lot of the bad press that rap music has always gotten is just a way to take the attention off of the continued systematic targeting and terrorizing of young black men in their own fucking communities. How do you glorify reality?

America is always looking for something to blame for the reason why it's destroying itself. First it was jazz that was destroying America, then it was rock and roll, then it was disco, then it was rap. But you know, I think America is destroying America. Our country is built on a foundation of rules and laws and belief systems that date back to the 1700s and the 1800s, back to the time of slavery. And it's fucking us up. It's breeding hate. It's deeper than a record. Hate goes way deeper than that.

A buddy of mine really ate a bitch. He literally killed her and ate her.

I had another homeboy who was killed in his house with his girl and all of his friends. I have another homeboy that was killed by a cop. So I ask again, who's glorifying what? That's what I've always wanted to know because this is the shit that's really going on. But I'm still waiting on an answer to that one. I'll probably be waiting my whole life.

The way I see it, I'm like G.E. I bring good things to life. I'm serious. I feel like it's every rapper's responsibility—just like it's the responsibility of everyone with a massive platform and a megaphone—to speak to the masses and expose the problems that they see in society. It's like they say in New York: If you see something, say something. Because if you don't expose the problem and don't let the world know that there is a problem that needs to be addressed, then no one will ever know that there was a problem in the first place, and it will continue. You bet your motherfucking ass. So it's my responsibility to speak the truth about what's really going on. That's what the community looks to me to do, and I owe it to them to deliver every single time.

And the shit goes deep. You ever heard the saying, *Save the land, join the Klan?* White people are arming themselves every day and they have been for years. Then, when you think about how easy it has been to get a felony drug charge and how hard it is to get a legal gun (never mind steady work) as a convicted felon, and you factor in the rates of incarceration of the black and white communities, you can start to see how deep this shit goes. These motherfuckers are not playing with us, for real. They can paint us as demons in the media and they can make the country scared of young black men, but this shit is way bigger than us, and it's way bigger than rap. Don't get it confused. We are the hunted. We are the motherfucking target. You better wake the fuck up.

And I don't believe in peaceful protest. Peaceful protest will just get your ass kicked again. It's just like in life. If a motherfucker is fucking

with you in the hood and you keep turning the other cheek, you're gonna keep getting your ass kicked. The only way to beat a bully is to fight. Win, lose, or draw, you've gotta fight. And I don't give a fuck what anybody says, the same goes for the state.

Honestly, I'm happy when I see niggas fight back. Like that shit in Ferguson was great to me. Or when they rioted in L.A. after the Rodney King trial? I love that shit. I'm for anything radical when it comes to the mistreatment of minorities. You can't lay down in the face of oppression. You have to fight in order for them to respect you, so I love it when motherfuckers want to go to war. I know it sounds crazy, but fuck it, I love it. So our music was a reflection of that. America thought it could push us aside, put its foot on our throats and keep us there, silent and dying, but the Geto Boys and all of our peers came out with one simple message: *Fuck that!* No matter what they tried to do to us, we were going to make sure that we were heard.

THAT OTHER LEVEL

I didn't want to be in a group when I first signed with Rap-A-Lot. I was a solo artist. I had my own crew—me, Bido, and the other guys I grew up running with on the Southside—and I had my own name. "Scarface" was a solo record that we made on our own. And it worked. The whole city fucked with that record, and that's why James came looking for me in the first place. I didn't need anyone else to make my shit hot. I was hot all on my own.

But as soon as I met him, I knew I wanted to do whatever it took to be like J. And even though it made the whole city madder than a motherfucker, especially on the Southside (I remember when my brother Warren got out of jail not too long after I'd signed, and he couldn't believe it; there was nothing cool about being cool with niggas on the Northside), I joined Rap-A-Lot because it was the only thing really happening in the Houston scene at the time and I was trying to get down, make some music, make some money, and make

a mark. When James offered me a chance to be in the Geto Boys and basically made it clear that the solo shit was going to have to wait, I went along with it because I wanted to be down and I wanted to be a team player. But that's why I'm not all over *Grip It!* I just did my parts and left. I wrote "Trigga Happy Nigga" for Bill, redid "Scarface" so Ready Red could add in the *Scarface* samples and we could switch the lyrics up just a bit to make it more of a Geto Boys song, and did "Seek and Destroy." I'm also on "Talkin' Loud Ain't Saying Nothin'," but I wasn't really into that record. "Seek and Destroy" was more of the type of shit that I was on at the time—just that straight MC terrorist, destroy-shit tip.

But James was a genius. I know I keep going back to it, but you've got to understand, not only did he know that he could take us and put us in a group, he knew that if he encouraged us to speak to the streets and fed us stories and material, the streets would listen. Even more than that, he knew how to make the business work, too.

One of the smartest things he did was make us practice our show before we ever even went out on the road. He had access to this little club in Houston called Obsession, and he had this one particular artist from out of town—I'm not going to say who because I don't know what the business arrangement was around that—come in and give us tips on how to make our live show live. And then J gave us images. I was the suit-and-tie, pimped-out gangsta with the cane. Willie D was the diesel, ass-kicking motherfucker who always had his shirt off about to tear someone's head off. Ready Red was the smooth DJ and Bushwick was the jokester. J came up with all of that. That motherfucker was brilliant.

The first tour we went on was with Ice Cube, Too $hort, and A Tribe Called Quest. We were always on the road with A Tribe Called Quest and we all became really cool. Cube had just put out *Amerikkka's*

Most Wanted and we went all over the South and Midwest with them, doing spot dates supporting their national tour. It was all of us, piled up six deep—me, Bill, Willie, and Red, plus the driver and our road manager, Big Chief—in a fifteen-passenger van, following their tour bus. We were making $2,500 a night, split four ways. It was rugged and no one in the group was getting rich, that's for damn sure, but we were out there making money performing our music. Needless to say, we didn't stay in the same hotels as $hort and Cube.

Once we got out on the road, though, we went everywhere, even to the markets that other acts were scared to perform in. We didn't give a fuck. And we were all strapped, always. We didn't know each other outside of the music and there wasn't any trust in the group, so we all brought our guns. We were crazier than a motherfucker, but we'd be out on the road in the van, riding with our guns like, *If this motherfucker gets out of line, I'm going to pop him!* We had the guns for outside conflicts, but we also had them to protect ourselves against each other. At least I know why I had my gun.

I remember one night, we were in Cincinnati and we got into it with the club security. I guess the crowd was getting too out of hand or some shit because they'd come up onstage and were trying to shut us down. We weren't having it. We wanted to rock so we started throwing microphones and fighting those motherfuckers. Well, when we got back to Texas we find out we have to have a group meeting with J at some spot way out in the country. We didn't know what the fuck was about to happen and Willie thought we should all bring our guns. I was with it. I know I wasn't trying to be in a situation where I wished I'd had my gun in retrospect. Fuck that. I wanted my gun right there in case some shit started to go down.

So we're riding out to this piece of land to go meet J, and Willie's driving when a car cuts behind us and starts following us on this little

dirt road. Willie wasn't having that shit. He cut off the road so quick and did a big-ass loop straight through the fields just so he could pull up behind that motherfucker, like, *I ain't trying to have anybody block me in!*

Years later, Bill dry snitched and told J that Willie had told everybody to bring their guns. Can you believe that shit? I never knew if there was anything going on with them at the time—if Willie and J had some other kind of beef or something else was up. I guess Willie was under the impression that J was going to do something, but I wasn't tripping. The way I saw it, as long as nobody takes a swing or starts shooting at me, I'm cool. Whatever they were going to do to each other, they were going to do. As long as it didn't affect me, I didn't give a fuck. The crazy shit is that after all of these years, I don't even remember if we ever did make that meeting. We might have, shit. Either way, no one got shot, at least not then.

AFTER RICK RUBIN PUT OUT THE GETO BOYS PROJECT, I FINALLY started working on my first solo album. At some point, I heard that we were off Def American and that Priority had picked us up, but I was so focused on my own shit, I wasn't even really thinking about the group. I knew N.W.A was on Priority, though, so I thought, *Well, shit, maybe we finally have a chance.*

"Murder by Reason of Insanity" was the first song that I recorded for *Mr. Scarface Is Back.* The West Coast Rap All-Stars had just put out the record "We're All in the Same Gang." Dr. Dre had produced the song and he'd used a sample of James Brown's "Untitled Instrumental." I thought what Dre had done was dope, but I didn't think he'd used the sample quite right. I thought he could have put the snares in some different spots, so when I came across that James Brown record while I was working on my own shit, that's exactly what I did. I flipped

the sample and recorded a version of the song in my apartment. That's where that album started.

I was working mostly with Bido and this guy Doug King, who was a producer and kind of like Rap-A-Lot's staff engineer. Doug had his own studio—Doug King Studios—over off of Hillcroft, and I was recording roughs at my place and then going over to Doug's studio to work on them and get them tightened up. Doug had a room full of records, an MPC60, and an EPS sampler, and that's where a lot of the beats I was making came from. I would sample something from his collection and then he would truncate them and make them smaller to where I wanted them to be. Then I would loop the tightened-up sample and make the beat.

Those sessions kind of set the blueprint for how it would go with a lot of the guys I would work with down the line. I was a student of the music and I always knew what sound I was going for, so I knew where to look to find the right sounds or the right sample. Like, I knew we could go to James Brown's "Say It Loud—I'm Black and I'm Proud" to get the "with your bad self" drop, or if I was looking for a certain string or harp sound, I would know where to find that, but I wouldn't know how to push the right buttons to get it all the way there. Whether it was Doug King then or someone like Mike Dean later, I always benefited from having some of the best technical minds around to help me out, back me up, and bring the sounds to life.

The second song that I recorded for *Mr. Scarface Is Back* was "The Pimp." Then I did "Your Ass Got Took," and then I did "Mind Playing Tricks on Me." I've got to give it up to my grandma for that one. She was always saying that—anytime she'd misplace her glasses or lose something, it was always, *My mind is playing tricks on me again.* She had a whole bunch of sayings like that, damn near a whole book's worth if you were to write them all down. So I just took that from her, married

it to all of the depression and darkness and paranoia that I'd always carried with me since I was a kid, put it over an Isaac Hayes sample that I'd found, and made the song. I thought it was dope, but I had no idea what it would become. Not at all.

At the same time that I was working on my solo album, the Geto Boys were also recording for a new album over at Sound Arts, which was another studio we were using a lot at the time. We weren't doing it the same way we'd done *Grip It!* I wasn't going to let myself get stranded on that ranch again. There hadn't been shit to do out there except look at horses and shit. So instead of holing up together out in the country until we got the album done, we were all working separately and then we'd just bring the shit we'd been recording independently to the table to see what we had. So I was going back and forth between Doug King and Sound Arts, working on both albums, when James comes by Doug King's spot one day to hear what me, Bido, and Doug had been putting together. I played him "Mind Playing Tricks on Me" and he thought it was cool, but he wasn't blown away. I played him some other records and he left, and I figured that was that and got back to work.

Well, then James takes "Mind Playing Tricks on Me" and a few other songs that we'd put together to California to play some music for Priority just to let them know we were working and to try to get a budget opened up for my solo album. He plays "Mind Playing Tricks on Me" and the people at Priority lose their shit. James comes back from that meeting and tells me, *Man, I don't know what it is about this song, but they love it out there.* The original version of the song was a solo record, but Priority had already opened the budget for the new Geto Boys album, so James decided he wanted to get Willie D and Bushwick on the record. Willie didn't want to do it at first because he didn't think the record would work, but he wrote a verse to it anyway.

I wrote Bushwick's verse and then Willie came through with the *I make big money, I drive big cars* . . . verse, and the people at Priority had been right: "Mind Playing Tricks on Me" was a smash.

I had no idea that song was going to be that fucking big. Shit, to this day I still never know whether or not a song is going to "work." I've always been much more focused on just making the music I like to make and the music I want to hear. I know what I like and I know when I think a song is dope, but when it comes to actually picking the songs that might work as singles, I leave that shit to someone else.

Well, "Mind Playing Tricks on Me" *worked* like a motherfucker. It was our first real hit. It wasn't just big in the South or big in the Midwest or big in the hood—it was big everywhere. It topped the *Billboard* rap chart. It broke into the Top 40. It got us on crossover radio. It let everyone know that there was a rap group coming out of Houston that could make some serious noise. I was twenty years old when we recorded that song. By the time I was twenty-one, it—and the Geto Boys—were fucking huge.

The year before "Mind Playing Tricks on Me" came out, I'll never forget it. We'd gone to New York for the New Music Seminar—which was this annual conference that brought all of the biggest players in hip-hop to New York for a bunch of panels and showcases and shit like that all over town. We performed up there and had gotten booed like a motherfucker. Those backpack-totin', true hip-hop motherfuckers didn't want to hear us. They wanted a cipher and to hear about the true mathematics, not a bunch of Texas niggas calling bitches bitches and rapping about slanging dope and beating niggas up. That shit wasn't hip-hop!

Six months after "Mind Playing Tricks on Me" dropped, we were back on the road with A Tribe Called Quest, this time as part of a tour called The Greatest Rap Show Ever. It was us, ATCQ, Naughty by

Nature, Queen Latifah, Leaders of the New School, Kid 'N Play, DJ Jazzy Jeff & the Fresh Prince, Public Enemy—everybody was on that motherfucker. And we played Madison Square Garden—the World's Greatest Arena—in January of 1992 and we rocked that bitch. That crowd knew every single word.

That was big. I remember walking off that stage with such a rush. Ground had been broken. We'd showed out in New York—the birthplace of hip-hop—and we'd been embraced.

REBEL RAP FAMILY

Even though I didn't grow up with the rest of the guys in the group, I've got a lot of love for them. We were drawn into a room and forced to record together for no other reason than James thought it would be a good idea. I've got to give it up to him for that. We made magic. I've been a Geto Boy since that very first session. Shit, really since I was born. And I'll be a Geto Boy for life.

But before we could all go to Madison Square Garden together and let those motherfuckers know what it really was, we had to finish the album. We had "Mind Playing Tricks on Me," and Priority loved that for the single so the Geto Boys album was a go. But a single doesn't make an album, and I spent the spring of 1991 going back and forth between studios working on the new Geto Boys album and my solo debut, almost inadvertently. I remember recording "Money and the Power" in Sound Art with James and his dad, Ernest, but I was doing most of my work out of Doug King's spot. I

wasn't really excited about making another Geto Boys album, I just knew that the faster we could get done with that, the faster I could get back to my own shit.

So we're all kind of doing our own thing, and then one night everyone had to go over to Sound Art for a group meeting. I don't remember who called the meeting, but I remember being in the studio's vocal booth, which was pretty big, and then Ready Red told us that he didn't want to be in the group anymore.

I knew he wasn't happy about the way the money was getting split up—shit, none of us were—but still. I wasn't expecting him to really just up and leave the group like that, especially not then, when we were just going in to make this next album. I was shocked. I think we all were. After all of the shit that we'd been through—all of the sessions at James's ranch, the time we'd spent together on the road, the bullshit controversies—to hear him say he wasn't trying to ride anymore, that shit hurt.

It was just like, *Damn, are you sure, Red? This is the one right here. Are you sure you don't want to be a part of it?* But he was sure. He'd recently gotten married and I guess he figured he'd had enough. Or maybe he thought he could take the little money he'd gotten from those first two albums, cash out, and keep it moving. Whatever it was, he was done.

Losing Red was tough. He was super dedicated to his craft. He watched a lot of movies and knew a ton of music and he was always good for a dope sample. The sample at the beginning of "Mind of a Lunatic" (*He's a paranoiac who's a menace to our society!*) was from the *Spiderman* TV show and that came from Red, as did all of the *Scarface* movie samples that ended up in the Rap-A-Lot version of "Scarface." He'd made those first Geto Boys albums and he really helped mold the early Rap-A-Lot sound. He was dope and he was also a great dude. I hated to lose him.

Still, as much as I was hurt, I also knew that Red leaving opened

up a whole new lane for me in the group. I'd already been producing and making beats, but with Red gone, I was like, *Shit, I'm really about to get some beats off now.* And that's exactly what I did. In addition to "Mind Playing Tricks on Me," I produced "Quickie," "Ain't with Being Broke," and "Fuck a War," and I contributed to the production of "I'm Not a Gentleman"—all for the Geto Boys.

We ended up calling that album *We Can't Be Stopped*, but if you listen to it, there's not a whole lot of "we" there. Willie and me wrote all of Bill's verses, like we always did, but the group didn't really work together when we were making the album, and instead of a whole bunch of Geto Boys songs, the album's really a whole bunch of songs by the individual members of the Geto Boys. I've got three songs— "Another Nigger in the Morgue," "Gotta Let Your Nuts Hang," and "Quickie." Bill's got three songs—"Fuck a War," "Chuckie," and "The Other Level." And then Willie's got his three songs—"I'm Not a Gentleman," "Homie Don't Play That," and "Trophy."

The Geto Boys are really only on three songs together, and one of those is "Mind Playing Tricks on Me," which would have just been another Scarface solo song if Priority hadn't fallen in love with it for a Geto Boys single. (Would it have been as big of a song without the whole group on there? Hard to tell, but we got everyone on there and it worked.) Shit, Red's even on the title track, and he wasn't even in the group when the album came out! James didn't care. Outside of "Mind Playing Tricks," it didn't matter who was on which songs or that we'd lost a member of the group. We had twelve records ready to go and we were going to put that motherfucker out, which was fine by me. I was ready to get back to working on my shit.

CHUCKIE

We really partied hard back then. It was a good time. We were young and we didn't have shit to do but get fucked up and make music. Our only responsibility was: make dope shit. And we were always getting into crazy shit. We'd get drunk and high as fuck, fuck what came behind it. We were all wild, but Bill was nuts. He always had his foot on the gas.

I wasn't there the night that he got shot, but I knew firsthand that Bill could fuck around and do some shit that would make you want to shoot his ass so quick you wouldn't even think twice about it. There's just something about him that will make you want to love him and kill him at the exact same time. For one, he's got a great heart. When Ready Red was living above James's car lot, which was nothing more than an office shack—nothing you'd really want to live in—Bill took him in and invited Red to come and live with him and his sister. But he just stays getting into some shit.

Not too long after I met Bill at the Rhinestone, he started hanging with Bido and me. He was always around, even before I was on Rap-A-Lot, and I started to feel like I was obligated to look out for him. It was kind of like we were brothers. I watched his back to make sure nobody fucked with him, and at the same time I tried to keep him from fucking over anybody who might come back on his ass. At one point during the early Geto Boys days, we even got a little two-bedroom apartment together over on Houston's northwest side. We had signs on our bedroom doors—his said LOVE SHACK and mine said FUCK SHOP—and we used to throw all kinds of crazy-ass parties over there, filming girls that came in and out of there and all sorts of shit. We were wild. But Bill was out of control.

He'd do shit like this. One night, Bido was driving back from the club and Bill was drunk in the backseat talking shit and just doing whatever the fuck he was doing. Then, all of a sudden, this little motherfucker comes climbing over the front seat and jerks the wheel and sends the whole fucking car flipping down the 610 freeway. Can you believe that shit? That's how Bill was living then. Straight up reckless.

But the last straw for me was when he got into it with one of the guys that was hanging with us at the apartment. Bill starts threatening to stab him and then he pulls out a fucking box cutter. I stepped in just trying to stop him from stabbing buddy and I grabbed his hand and he ends up cutting the shit out of me! Sliced my whole finger up and damn near cut off my thumb, and we weren't even the ones fighting. I was just trying to get him to calm the fuck down. Of course fucking my hand all up didn't slow Bill up none and his crazy ass ends up jumping out of the second-story window just to go after that dude. Jumps out the fucking window with my hand all bleeding and shit. Man, from that day on, anytime he'd get going, talking about how he was going to fight somebody or do this or do that, I'd just be like, *Man, shit. Jump then, nigga. I don't give a fuck. Jump.*

But that was Bill. Nice and funny as shit one minute and then a little fucking demon the next. So when I heard that his girl had shot him, I wasn't surprised at all. And I know his story is that he was depressed after drinking all day and decided he wanted to kill himself but knew the life insurance wouldn't pay out for suicide so he provoked her, and if that's his story and he's sticking to it, cool. I wasn't there. But knowing him and knowing her, I think that bitch shot him for real, and he just happened to live. It ain't like she shot him in the arm or the leg or the foot or anything like that. She shot his ass in the face with a .22. She wasn't playing. And I don't care what anybody says, no one wants to get shot in the face. Fuck that. There ain't no way. She popped his ass right in the eye because of some shit that was going on between them that had nothing to do with that day. I can't say for sure because I wasn't there, but that's what I believe.

I got the news that Bill had been shot from Bido. And when I got off the phone, I thought, *Well, that's the end of that story.* He'd gotten shot through the eye, and I just knew he was dead. There was no way he was going to live through that shit, and if Bill died, the Geto Boys were done. But I should have known better. I knew Bill was a tough little motherfucker.

Bido was in the hospital all night, but I didn't get there until the next day. Big Chief, our manager was there, and so was Cliff Blodget. I never knew what Cliff's role was at Rap-A-Lot, I just knew that any time we asked him about anything, his response was always the same, *Let me get with J.* It didn't matter what it was, it was always, *Let me get with J.* Well, whatever his deal was, that day he was the photographer.

Someone must have told us to dress like we were going to a photo shoot because we had all of our gear on, but once I got to the hospital and saw how fucked up Bill was, I wasn't down with that shit. It was too raw. That's why I have that look on my face in the picture, like, *Holy fuck!* But I was a team player. They had us go get Bill out of his

room and bring him into the hall. That's not even his gurney in the photo. Then Chief had Bill take off his patch so you could see how fucked up his eye was and Cliff took the shot. We didn't know what we were shooting for, but J sure did. I don't know if he knew it that day, but when it came time to make that call, he called it. He knew it was one of those images that would make you stop what you were doing as soon as you saw it and take a closer look like, *What the fuck?*

And that's how we ended up with the cover of the Geto Boys' *We Can't Be Stopped*. It's one of the most famous—and infamous—images in hip-hop history. Once again, James had been right. That photo and the story behind it would have gotten us plenty of attention on their own, but combined with "Mind Playing Tricks on Me," *We Can't Be Stopped* lived up to its title in every way and went gold almost as soon as it dropped. You could boycott us, ban us, dis us, dismiss us, attempt to disband us, and even fucking shoot us—it didn't matter what you tried to do. We couldn't be stopped, for real.

MR. SCARFACE IS BACK

With *We Can't Be Stopped* wrapped up, I was finally able to focus my attention on finishing my solo debut. And with Red no longer in the group, I actually ended up producing the bulk of it myself. Every beat except "I'm Dead," "Born Killer," and "Mr. Scarface Is Back" is mine. I coproduced "Diary of a Madman" with a buddy of mine from New Orleans, Big Ro, and I think Doug King might have done the drums for "Good Girl Gone Bad," but I did the rest of that album on my own.

I've got to give it up to Doug, though. He was a great engineer and he really showed me how to get the sounds I was looking for out of the records I was making. Before I'd gotten with the Geto Boys, I'd been making most of my beats with Bido, but when I was working on that first Scarface album, Bido was busy working on the new Geto Boys project. Bido would come through and hear the shit Doug and I had been doing and help out a bit, but he was much more focused on getting that Geto Boys album wrapped up. My production was heavily

influenced by Dr. Dre and Marley Marl. I'd find a nice, ugly breakbeat that I would take and then loop, but without Doug, I would have been fucked. He really helped me get my albums together and make my shit tight.

It'd been four years since I'd signed to Rap-A-Lot, and my solo album was going to be the fourth album I'd been a part of since getting down. We were getting it in! And I was always high. I'd been getting high my whole life, no exaggeration. I can't remember doing shit sober.

When I was eight years old, my uncles would come up behind me and squeeze me so I couldn't breathe and blow me charges of weed smoke until I blacked out. They called it an Indian charge. So I was smoking dope, way back then as a little kid, and then as I got older, I just graduated to different shit. I started sniffing paint and huffing glue and then fucking with all sorts of hallucinogens like mushrooms and LSD. We were even doing this shit called rush, which was a popper you could get from head shops. We were down to try it all. Shit, we were so down to get high back then, if we didn't have some weed to roll a primo, we'd just take the dust that collected on the bottom of the Pyrex bowls and smoke that shit off the top of a goddamn soda can. There wasn't really shit that I wasn't down to do at least once except maybe heroin or methamphetamines. I always steered clear of that shit, but otherwise, I didn't give a fuck.

So when it came time to write records and make music, I'd just take that feeling of being fucked up and combine it with all of the crazy shit that I'd done, seen, or been through in my life, mix it up, and let it burn in the booth. I wasn't scared to be fucked up and I wasn't scared to be vulnerable. I wasn't scared of shit, and I think that's what drew people in. Back in the summer of '91, I was just getting started, but you can already hear my approach starting to

take shape in songs like "Mind Playing Tricks on Me" and "Diary of a Madman." Everyone always talks about "Mind Playing Tricks on Me" because it broke us so big and was unlike anything anyone had ever really heard, but "Diary of a Madman" is one of the deepest songs I've ever written. I'd just gotten into it with my girlfriend when I wrote that record. I'd done some super-ill shit to her and I felt horrible about it. I was really hurt by the whole thing and I just wanted to go off and hide in a fucking shell. Instead, I just took all of that anger and confusion and regret and poured it into the song. I always wrote my life, and that was no different. It was dark from the title on down. And it was all too real.

In fact, the only thing that wasn't real about that first Scarface album was the coke on the album cover. That shit was flour. But those guns sure were real. We shot that photo out at James's ranch. We were just out there one day shooting pictures and shit got out of hand. But like I said, we were always strapped. Shit, back then we were even using our guns to get the gunshot sounds we wanted on the records. We'd just go out to James's property, drag the mics outside, and let off. We were that raw.

That album cover was hard as a motherfucker. And coming off of the *We Can't Be Stopped* art, too? Man, you couldn't tell us shit! But as tough as that photo was, it was the cover of *Mr. Scarface Is Back* that ultimately fucked up the group. I think there might have been some other shit going on because Willie was unhappy with the way things were going even before he saw the art. I know he wanted more money. We were cutting up those Geto Boys checks so many different ways— splitting everything that came in like five or six ways, plus paying out management and publishing, both of which James controlled—that checks would finally end up in your hand, and it'd just be like, *Damn, really?* So I think Willie was already trying to eliminate all of those

hands in his pocket—or at least cut them down a bit—but when he saw the cover for *Mr. Scarface Is Back* and that it had SCARFACE OF THE GETO BOYS in big letters at the top, that pushed him over the edge.

Willie wasn't feeling it. I don't know what it was. I guess maybe he felt like he had as much of a claim to anything the Geto Boys had built as anyone, or maybe he wasn't feeling the way I'd been half in, half out on *We Can't Be Stopped*. Or maybe we were just young and he was already upset about some other shit and that's just how it gets sometimes, but he wasn't having it.

I remember being on a conference call about it and he was like, *Nah, you can't put "of the Geto Boys" on there. Just put "Scarface" on there.* He was adamant about that shit.

I didn't really care either way, but I knew having SCARFACE OF THE GETO BOYS on there was going to be huge. The "Scarface" song was still so fucking big, and a lot of people still didn't know that I had recorded it. Everyone still knew me as Akshen. For a long time, people thought Ready Red was Scarface. They'd come up to me and be like, *What up, Akshen? Where's Scarface?*

I'd never released any of my own music as Scarface, but *Mr. Scarface Is Back* was going to change that. And with that line OF THE GETO BOYS right there on the album in big type, no one would ever get it fucked up or confused again. There wasn't any way around it. I was Scarface of the Geto Boys. End of discussion.

And I guess that was the way James saw it, too, because that's exactly what he told Willie D on that call.

We've got to have OF THE GETO BOYS on there.

And James was the boss. That's how the album came out, and by the time it did, Willie D was gone. He was still on the label, but he was going solo and he was no longer a Geto Boy. I respected his decision. You can't help but respect a man who's about his business and stands

up for his. But with no Willie and no Red, as far as I could tell, the Geto Boys were done. We were all going to have to step up and do our own thing, and that made me nervous. I looked up to Willie. I knew he was cold. He had skills. I didn't think there was any way my solo albums could stand up to his. I knew I was going to have to step my shit up to compete. His decision changed my life.

PART THREE

THE DIARY

CHAPTER 15

HOUSTON AND HIP-HOP

People always talk about their rap Mount Rushmore—you know, the four MCs they'd carve in stone as being at the top of the game? But it would be impossible for me to name all of my influences. Real talk, if I ever had to do that, you'd have to give me much more than a mountain—you'd have to give me a whole goddamn mountain range. My top four would turn into a top ten, which would turn into a top twenty, which would turn into a top fifty, and the next thing you'd know, the whole fucking Rockies would be cut up with faces of my favorite MCs.

Every single rapper that came before me—good or bad—and even the ones that came after me have all helped to mold me into the artist that I was then and the artist that I am today. For real. So for me to talk about my influences, you'd have to go all the way back to the very beginning, to the Sugarhill Gang and "Rapper's Delight," Kurtis Blow, Grandmaster Flash and the Furious Five, Melle Mel, and cats

like that. They brought a new style—a whole new avenue of music—to the world. Those were the forefathers of the genre. They created hip-hop, and it was revolutionary. Without them, I wouldn't be me because when they brought it, it was like, *Damn, I really want to do this.*

But if they laid the foundation, what really made me want to take it seriously was hearing highly skilled MCs like Kool G Rap, Big Daddy Kane, Rakim, and Chuck D really pushing the form with their wordplay and rhyme patterns and bringing their unique voices and deliveries to the game. They were all so sick and so sharp—just straight killers on the mic. And I wanted to be like that. I wanted to be Chuck D, Rakim, and Big Daddy Kane balled into one. Give me Chuck's delivery, Kane's skills, and Rakim's rhyme style, plus Willie D's content—that's what molded me. I wanted to talk shit, be political, and spit some gangsta-ass shit. That's what I was after.

And then Ice Cube came along and fucked the whole game up. As soon as I heard "Straight Outta Compton," I knew that was the music I wanted to make. In fact, that's the song that inspired me to make "Scarface." It was just so raw and so mean, and Cube was a beast. He had the whole package—his wordplay was tight, he had a great voice, he spoke straight to the streets, and his raps were tough as a mother-fucker. I loved Ice Cube. He was a little older than me and I know a lot of dudes won't admit to trying to emulate other people or to trying to follow in the footsteps of someone, but I looked up to him growing up. I really think he's a better rapper than I am. There were a couple of guys that I really looked up to—guys like Big Daddy Kane, Chubb Rock, Chuck D, and Ice Cube. Those were my classmates in my mind, my contemporaries. If I was going to be compared to anyone, I wanted to be compared to them. But beyond that, my motivation really came down to two things: I wanted to live like James and I wanted to rap like Ice Cube. If I could pull that off, I knew I'd be good.

I remember going to L.A. and hanging out with Cube for the first time. He had a black Nissan 300ZX. Shit, as soon as I got home, I bought a red one. Then, I remember being in L.A. working on one of my solo albums, and I ran into Cube and he had a black BMW, one of the newer models. As soon as I got home, I went and bought myself a white one. I wasn't biting, but Cube was doing it for real and I was definitely taking notes.

I know everyone's always made a big deal about us being from the South, but I was never really concerned about where I was from. Not like that. When we were coming out, there was definitely a New York bias in hip-hop, but I always thought New York had a legitimate claim. They created the shit and everyone else was following—they got to dictate the terms. I'm not saying it was fresh to just write someone off because of where they were from, but New York had set the bar and if you didn't hit that bar or raise it, then that was on you.

At least, that's how I was looking at it. I didn't give a fuck that I was from Houston. If I had been from New York or California, I wouldn't have given a shit about that either. I didn't want to be categorized, I just wanted to be a part of what was going on, and I wanted to be taken seriously at the same time. I always felt like assigning a region to the music me and the Geto Boys were making was just another way of pushing us to the side or somehow putting us off or putting us down, and I wasn't with that shit. Don't judge or put a value on my music simply because of where I'm from or tell me you think my shit is dope "for something coming out of the South." That shit is insulting to me. If my music is good, fuck with it. If you have a problem with the music I'm making, fuck you, then. Don't like me or dislike me because I'm from Texas, like me or dislike me because of the music I make and the way I rap and what I rap about and how I bring it. And if you can't appreciate me for that, then I can't help you. I'm not

interested in being the best in the South. I'm interested in being the best. And I think that was the attitude for all of us—from J on down. We didn't want to make the best music out of the South, we wanted to make the best music period, to the point where you had to fuck with us no matter where you were from. And we worked our asses off to make that true.

Back in those early days, there wasn't a lot of shit coming out of Houston. The city—like the rest of the South outside of the shit Luke was doing with 2 Live Crew and Miami bass—was kind of dead. Anything coming out of Houston sounded like a bunch of kids doing nursery rhymes. Motherfuckers might as well have been rapping the alphabet compared to the shit coming out of New York. It was just a whole different animal.

Our only real outlet for hip-hop was this radio show Kidz Jamm, which was on Texas Southern University's KTSU. This was pre-Internet, so it would take forever for records to get down to us, but Kidz Jamm was jamming. It was on every Saturday morning from ten to two, and it had some of the best DJs in town, including Terry T (who went on to be the rapper King Tee), Marcus Love, and Lester "Sir" Pace. Jazzie Redd also DJed up there for a bit. Kidz Jamm was the one place we could hear all of the new music, both national and local, and even though it was called Kidz Jamm, they played all of the grimy street shit that we all wanted to hear. I bet it was one of Houston's most highly rated radio shows back then. It felt like the whole damn city was tuned in.

The other big outlet for us was a local DJ, Darryl Scott. Darryl was from the Third Ward and he was a mixtape king. He ran the city in the early eighties, DJing all of the hottest clubs and hustling his mixtapes all over town. He would take all of the latest records—all of the shit you couldn't hear on the local stations like Magic 102 and Love 94—and he'd mix them all together with this technique he invented

called the chop, which was like a short stab of sound from the records (longer and heavier than a typical DJ scratch) rather than a smooth blend. The radio was playing shit like "The Message" or "Rapper's Delight," but if you wanted to hear Scorpios or Kool Moe Dee or shit like that, you either had to turn on Kidz Jamm or get you a Darryl Scott tape, and Darryl's tapes were dope. He had a shitload of them, too—you know, editions one through fifteen through twenty-three through twenty-three and a half, and on and on—and he made a killing. If you had ten dollars to either buy an album or a Darryl Scott tape, you were getting the tape. He was platinum in the hood before platinum was platinum just from pushing those tapes all over town.

Motherfuckers all over the world know Houston for Screw Tapes, but it was Darryl who really made Houston mixtapes a thing. Darryl chopped them up and then Screw came on the scene and slowed them down, and it was the marriage of those two styles that gave Houston mixtapes their sound. Now if you want a "screwed" version of something new, you're going to get it "chopped and screwed" or "chopped and slopped." Either way, that chop is going to be in the mix.

When it came to FM radio, though, that shit was a mess. Hip-hop was so far from getting spins back then I'm not even sure they played L.L. Cool J. Good fucking luck hearing anything local. The only people who really looked out were Jimmy Olson, who was a DJ on Kiss 98.5, and Greg Street, who was at Magic 102. They broke the Geto Boys locally. After the Ghetto Boys came out with "Car Freaks" (that's Ghetto with the *h*, before me and Willie got down with the group), the next big record out of Houston was Captain Jack's "Jack It Up." (He was signed to Rap-A-Lot at one point, but that didn't last.) Then R.P. Cola came through with "The Cabbage Patch Dance," and that's when the scene started to grow. K-Rino was out here really early, doing it. And so was Raheem. Ganksta N-I-P and Big Mello started

making noise not too long afterward. Then the Ghetto Boys dropped *Making Trouble* in early 1988, I got the "Scarface" record off and hooked up with Rap-A-Lot, and it was on.

I think people who aren't from Houston or who have never spent time there either forget or fail to realize that Houston is a big-ass fucking town. It's not New York or L.A., but it's the fourth-largest city in the U.S., and that's no recent boom. Houston has been a big city for a long, long time. And because of that, it's always been a destination. We get all sorts of people passing through Houston, from all sorts of places, and they always bring their influences and then we mix that with what we've always had going on and that's where the city's culture comes from.

The Geto Boys are a great example. Ready Red and Bill were both from the East Coast (and so was Johnny C back in the group's early days), and then you combine them with Willie and James, who were from the Northside, and with me being from the Southside, which was like a whole other city unto itself, and you end up with a group that could take that Northeast hip-hop influence and put it in a mix that spoke to the whole city, not just the Northside or the Southside.

But of course it went beyond that. When we were coming up, we were always getting music from other cities, however we could. I had my cousin in New York feeding me records, but then the whole city was getting hip to the shit coming out of New Orleans—guys like MC Thick, Tim Smooth, Buss Down, and all of that. And then when Cash Money started making noise later, we jumped on that quick because they were jamming like a motherfucker. Plus James was going all over the place and bringing back all of the shit he was hearing and we were pulling all of that together and making something new—something that spoke to us, for us.

We just had one rule: no biting. You never wanted to sound like

anybody else. Being influenced by someone is one thing, but you could never copy. That shit was wack. If you were following someone else's style, you always had to put your own twist on it. We were inspired by Run-D.M.C., but if Run-D.M.C. was clicking in and out and trading lines during verses, we didn't want to do that. We wanted to find our own way and our own style of tearing shit down.

And that went for everything, from making music to simple shit like the color of your car. If a nigga painted his car orange, the last thing you wanted to do was paint your car orange. I think that's one of the things that's helped the Houston scene thrive over the years. The city is full of super-solid motherfuckers and there ain't nothing fake about it. It was all about finding your own style and claiming your own space and standing on your own two as an individual and as a man. You never wanted to be confused for anybody else. Being authentic has always been key.

We also took rapping seriously as fuck. I can't speak for the other cities in the South and Midwest that started developing their own scenes around then, but in Houston, it was just like in New York: you had to know how to rap. You couldn't just be out here doing that A-B-C shit. Hell no. You'd get your ass clowned all the way back to your mama's house. That shit wasn't going to fly. But with us, it quickly went from trying to outrap each other to telling it how it is and giving a real voice to the ghetto. And once we made that shift, you had to back your shit up. So that's what it was about—going in the booth and speaking your mind, fuck what another nigga felt about it. And you can't fake that.

I took all of that shit to heart from jump. If I didn't want anything else out of the rap game, I wanted Houston to know what I was about and I wanted New York to respect my flow. And I wanted to be compared to the greats. When someone said, *Who's on the rap Mount Rush-*

more? I wanted my name to come up in the conversation and to start an argument about whether or not I'd earned my place. If I could just get that, then I'd done my job.

To me, the coldest thing in the world would have been to go unrecognized—where someone would listen to a song or an album or a verse and just write me off, like, *Oh, he ain't saying nothing.* I refused to let that be me. From the moment I first laid breath on the mic, I had to be the most consistent, most authentic, realest, baddest, coldest motherfucker in the game. That had to be me. Had to be.

DIARY OF A MADMAN

I've always been a writer.

I remember my fourth-grade teacher, Mrs. McKluskie, teaching me the basics of storytelling and that every story had to have an intro, a rising action, a climax, and then a conclusion or else it wasn't complete. That's a lesson I've carried with me my whole life. But I wrote beautifully, even then. I remember when I was in sixth grade, I wrote a poem about spring or some shit and it was so good that all of my teachers thought I copied it from something. They called everybody—the principal, the assistant principal, the other teachers, everyone—into the classroom to hear me read that shit to them because they thought it was so amazing that a twelve-year-old could write something that complicated and intricate.

But what can I say—it's in my blood. This isn't a fluke or a gimmick. This is what I was born and bred to do. My uncles are stone cold with the pen and my cousin is one of the greatest songwriters of all time.

My whole family was musicians and artists. It's like breeding German shepherds. When you're working with that kind of bloodline, at some point you're going to run into someone like me. And if it hadn't been me, it would have been the next child or the one after that or the one after that. It was inevitable.

And I know that probably sounds cocky or conceited, but I'm not trying to talk shit or build myself up. I know that I'm one of the best who's ever done it because the people I look up to—Ice Cube, Jay Z, Nas, Dr. Dre, Whodini, Slick Rick, Big Daddy Kane, all of the greats— have all told me that they fuck with what I'm doing and that *they* look up to *me*. And I'm thankful as a motherfucker for that, too, because I know it's a blessing from a higher power that I can sit here some twenty-five years after my career first started and still outrap damn near anybody you put me up against. That has nothing to do with me. That's a gift that was handed down from above to my family and then to me. It's humbling, and my gratitude runs deep.

But I also know I got here because I gave it my all. I'm talking every piece of me, well past the point of pain. I gave everything I had and then I gave some more. And after twenty-five years in the studio, I'm only just recently starting to pull back and retreat a bit to allow other things into my life. But even that hasn't affected how I write. To this day, when I sit down to write a song, I think about structure and then I dig deep and pull everything I have into it and follow my heart wherever it needs me to go.

Ninety percent of my songs are personal, so personal in fact that sometimes it almost hurts to write them down. But I also feel like I have to take the whole process personally. Not only is that how I work through all of the shit that's going on in my life, but I also believe that's how you make the best shit. To me, the best songwriters of all time are people like Lou Reed, Bernie Taupin, who wrote all of Elton John's lyrics, and Nina Simone. They leave it all on the paper, like a

boxer is trained to leave it all in the ring or a football player is trained to leave it all on the field. From listening to them and just loving their music my whole life, and from watching my family work—through all of them, I was taught to do the same.

I don't think I would have been able to make the music I've made if I was always holding something back, no matter how small. So whether it was my struggles with depression, my drug use, my regrets about my relationships or my missteps as a man, the pain and paranoia I felt when I saw my friends get killed or when I heard about another family torn apart by violence in the hood, the rage of being oppressed and suppressed—whatever it was, I always put it all out there in the music. I always wrote my life.

I SEEN A MAN DIE

Nineteen ninety-two should have been a great year. *Mr. Scarface Is Back* had not only established me as a solo artist, it had solidified my name and my rep. I was one of the first MCs—from anywhere—to come through and talk that street talk on record in a skillful way. While everyone else was talking about how good they could rap, I was talking about how good I could rap in that dope talk, and anyone who knew anything about anything had to fuck with me when they heard it. And a lot of motherfuckers heard it. *Mr. Scarface Is Back* went gold in just a few weeks after its release in late '91.

Then in February of '92, *We Can't Be Stopped* was certified platinum by the RIAA. Platinum! It's a motherfucker what a hit will do for a project. But instead of celebrating as a group, the group was fucked up. And by fucked up, I mean dead. After all of the shit that the world had thrown at us, it turned out the only thing it took to stop the Geto Boys was ourselves.

Instead of following up the success of *We Can't Be Stopped* with another Geto Boys album, Willie was off recording *I'm Goin' Out Lika Solider* while Bill worked on his own solo debut, *Little Big Man*. But James wasn't going to let a little group falling-out fuck with the label's dough. When Willie and Bill's albums were ready to go, he dropped them both that fall. And then in November, he took a couple of unreleased tracks and put together the greatest-hits collection *Uncut Dope: Geto Boys' Best*. We didn't record any new music specifically for that album, but it did include two *new* songs: "The Unseen," which was the first Geto Boys song to feature Big Mike (in place of Willie D), and my solo record "Damn It Feels Good to Be a Gangsta."

"Damn It Feels Good" was a *Mr. Scarface Is Back* leftover, but we released it as a single and shot a video for it and the fans were fucking with it from jump. I really think it was that song, plus "Mind Playing Tricks on Me" and "A Minute to Pray and a Second to Die" from *Mr. Scarface Is Back*, that really solidified the style I've been most associated with throughout my career—dark, vivid storytelling that's in touch with the streets and haunted by a conscience (and that's a bit more laid-back than the earlier stuff when I was out here just trying to beat motherfuckers' doors down and kick their faces in). Years later, Mike Judge and his 1999 film, *Office Space*, would make "Damn It Feels Good" one of the more recognizable songs of my career. I don't remember the specific session when I wrote that song, but I know this for a fact: when I wrote it, I definitely wasn't thinking about beating the shit out of a laser printer!

As for me, with no Geto Boys album in sight and *Mr. Scarface Is Back* less than a year old, I spent most of 1992 on the road chasing show money. We'd sold over five hundred thousand copies of *Grip It!*, which was unheard of as an indie, and gone platinum with *We Can't Be Stopped*. My solo debut had gone gold but the record sales still weren't

paying my bills. I certainly wasn't seeing rap-star money, at least not how I thought of it at the time. If I wanted any real bread, I had to get up, get out, and go get it on my own.

And that's exactly what I was doing as 1992 turned into 1993 when shit went super fucking haywire in the early hours of January 17, 1993, at a Waffle House in Shreveport, Louisiana.

Now, I don't know what you know about Shreveport, but if you think that shit's sweet just because it's a small town in northwest Louisiana, then you don't know shit about shit. And that goes for everywhere you go. It's real in the field—always has been and always will be. It ain't no mystery and it ain't no joke, and if you think these boys are playing out here, then you have another thing coming. The shit can pop off on any given Sunday, and you better be ready, whichever way it goes.

Going into it, there wasn't anything special about that night. I had a show in Shreveport, just like all of the other shows I'd been doing throughout the South and Midwest. I wasn't touring. It wasn't anything big and organized like that. I was just hitting spot dates. Nine times out of ten, I'd get booked for a show somewhere in Texas or a neighboring state and we'd load up early in the day, drive to the show, rock that motherfucker, collect the bread, grab a bite and maybe fuck with a few bitches, and then drive back to Houston that night or early the next day.

There wasn't much to it. It'd be me, my manager B.W., my brother Warren, my cousin Jamal, my homeboy Lil Joe, my good friend Rudy Sanders, and a few other motherfuckers. We never had any security. We didn't then and we still don't today. We just kicked ass. That was our security. If we were gonna fight, then goddammit, we're gonna fight. If the guns were coming out, then the guns were coming out. It ain't like shit changed just because we were making music. We

were ready for whatever. But no matter how ready you are, whatever doesn't always go as planned.

So we get to Shreveport and do the show and after it's done, we went to Waffle House to get something to eat. We're in there with one of our O.G. partners chilling when this dude comes in trying to play us, asking stupid questions like, *Where Scarface at?* and shit like that, knowing damn well I'm sitting there right in front of his face. I guess he was trying to be a bad man or play the tough guy. Well, I don't remember exactly what happened that escalated the whole situation, but suffice to say we weren't going to sit there and take too much of that shit and that motherfucker escalated and everyone starts heading outside to handle it and that's when it popped off. The place erupted and the whole parking lot starts brawling. Everyone's fighting like a motherfucker and then one of the dudes they're with pulls out his pistol and starts shooting and pops me right in the leg, just above my knee.

As soon as I got hit, I yelled out, *I'm hit! I'm hit!* And one of the guys we're with grabs me and pulls me inside to make sure I was straight. But once that shot went off, the place lit up. Motherfuckers were shooting in the parking lot, shooting inside the building, all sorts of shit. Bullets were everywhere. I was out of it, trying to lay low and make sure I didn't get hit again, when Rudy grabs a gun from one of the other guys that had one and wasn't doing shit with it and heads outside to light those motherfuckers up and try to get them off of us. Next thing you know, this off-duty cop raises up and shoots my boy in the back. Capped him right there, while Rudy was just out there firing back in self-defense. Instead of going out there and trying to do something about the motherfuckers shooting up the place, he shoots the one guy trying to provide cover for everyone in the fucking back.

Well, shit, Rudy was dead before the ambulance even showed up. I'd only known him for a few years, but we were young and those bonds grow quick. He was a great fucking dude and looking back on it, I always remember how sad he looked when we went to pick him up for the drive. He just had that look like he didn't want to go. I was in the van and he was at the door looking sad as fuck, and I just remember yelling at him, like, *C'mon, man, let's go!* And he loaded up and he never came home, ended up dead at twenty-three over some bullshit in Louisiana because a cop shot him in the back. And they called that shit justifiable homicide, too. There wasn't shit we could do but say good-bye and try to move on.

I checked out of the hospital that night. I remember Suge Knight came to check in on me before I went home. I don't know what he was doing in Shreveport that night, but we'd gotten cool with Death Row when we were out in L.A. and Big Mike and 3-2 were working with Dr. Dre during *The Chronic* sessions. I guess he heard I'd been shot and decided to stop by. Man, Suge sure had them motherfuckers scared to death back then! But we weren't scared. We already knew what it was. I think that's why he had so much respect for us. He knew we weren't about to back down for no man.

It's only a four-hour drive from Shreveport to Houston and they'd given me some good dope at the hospital so I slept most of the ride. But every time that medicine wore off, that shit burned like a motherfucker. Man, it hurt! That's the only time I've been shot, but I'll tell you, getting shot once is enough for anybody. After that, I knew there was no way in hell I was going to get shot again. Fuck that. That's why I'm always shooting first every time.

But I'd been lucky. One of my buddies got shot in the leg once and it shattered his femur and tore his whole shit apart. I was still young— just twenty-two—and my legs were still strong from my football days,

so when the bullet hit me it didn't break my leg. Instead it popped off my muscles and bone and worked its way down toward the outside of my knee. They never took it out and it's still in there today.

It took me a while to be able to walk regularly again, and I spent some time in a wheelchair. I remember doing a show in Chicago right after I'd gotten shot with Big Mello pushing me around that motherfucking stage while I rapped. Shit, those people went crazy over that! After the wheelchair, I switched to crutches and then I was able to use a cane, which was part of my image anyway. Originally James had given it to me as a prop, but in the early part of 1993, I needed it for real.

The next few months were dark. Rudy was a funny-ass dude, and he was one of my best friends. He'd been living with me at the time, and it broke my heart knowing that we could have just left his ass in the house and he could have been there when we came home.

But we were young—kids, really. You couldn't tell me shit. And there aren't any do-overs in life and death, and when death comes, it comes—there's no stopping it. When I think back on what happened in Shreveport, all I know is that things would play out differently if I found myself in a similar situation today. And that comes with experience. You find yourself in enough fucked-up situations and it won't take long before you learn how to deal with shit and recognize it when it's happening. You don't really have a choice—it's either that or someone will check you out quick.

One thing I know for sure: there's a difference between going to war with a motherfucker in his hometown when you're a kid and going to war with a motherfucker in his hometown when you're an adult. You've got to recognize where you are and what you're doing and you have to know how to move around. In my experience, when you're on another motherfucker's turf, if you keep it street legal and

stay out of his way, nine times out of ten he'll stay out of yours. And if it just so happens to be that tenth time that it goes the other way, you damn well better be prepared, because it can always go the other way.

But on some real shit, a big part of being real is not inviting the bullshit. You go out there trying to stir shit up, and I guarantee you that shit will find your ass. As for me, I know I ain't no motherfucking hero. I'm not about to jump in front of a bullet that wasn't meant for me just to jump in front of a fucking bullet, and I'm not about to subject the people that I'm with to have to jump in front of a bullet for me either. When I see some stupid shit jump off that ain't got shit to do with me, I'm going to get the fuck out of the way. And I suggest you do the same.

At the same time, when it comes right down to it, my motto has always been: *My nigga, I'm ready to let it go. Are you?* No bullshit, that's what it takes. When it really goes down, you have to be ready to go all the way—it's the only way. So that's where I'm at with it.

I'm ready to die. Are you?

HAND OF THE DEAD BODY

My grandmother always told me that being able to accept death was the sign of a good Christian. I gave up being a good Christian a long time ago, but I've never forgotten the lesson. I was raised to believe that I was born just like you, and just like you, I was born to die. It's something that I've always known, for as long as I can remember—it doesn't matter how or when you go, at some point we've all got to go. It's written in all of our books, on page one before we even open our eyes and take our first breath, that with every breath we take, we're one breath closer to our last. And I'm no different. I will die. There will be an end to Brad. That will be that and I will be no more. And just like you, I can only hope that I've made my mark before I go.

I've always been infatuated with death. I'm drawn to the permanence of it and the unknown. It's incredible to me that after all these millions of years of human life, we're still no closer to understanding what it's like on the other side, or whether there's even another side at

all, or if it's just nothingness. But even that—the cold, vacant reality of true nothingness—is something that none of us has ever known.

Growing up, I would imagine waking up in a coffin, six feet underground and surrounded by darkness—dead, but aware, and unable to escape. And I'd wonder what it would be like to see, feel, speak, taste, touch, hear, and know nothing at all. Or I'd find myself wondering about the people who got shot in the street or died in a car crash, wrapped around a telephone poll. Do they know that they died a violent death, or is all death the same? Does it feel different to get shot in the head or to die asleep in a hospital bed or is it all the same big scream or hush?

These were the kinds of things I would think about in my bed at night as a kid. And even sometimes today I find myself awake, late at night, wondering the same things. Sometimes I even wonder if I'm dead or alive or if we're all dead and this is all some elaborate dream. Tell me, how would we even know?

But even then, and in the face of life's greatest unknown, I've never been scared of death. It doesn't make sense to me to fear the inevitable, and I've always believed that whatever I've got to face—whether it's a crook or a cop or a crooked-ass cop or just time working its way through life—I'm going to face it head-on. And if I've got to die, well, then I guess I've got to go. The way I see it, you can die in your bed or you can die in the streets, pick one and live and die accordingly. For years, I picked the street.

At the same time, suicide was never out of the question. I thought about it constantly from the time I was thirteen until I was about twenty-four or twenty-five years old. I couldn't stop. One day things would be going fine and then the next day shit would be all fucked up. I'd feel like the world was about to end and there wasn't any point to life. And after Rudy got killed, it just got worse.

When I was younger, I'd fooled the doctors at Hermann and HIH and gamed my release, but it wasn't as if that made my depression go away. And once I was back out there on my own, I couldn't fool myself. I never really knew how it was going to go with me, but when it got bad—it got bad. I was popping pills like jelly beans and fucking around putting cocked, loaded guns to my head. I never did pull the trigger, but I put myself in some really dark, fucked-up places, and once I was there, I never really did anything to try to get myself out.

I'm still not sure I've ever been truly happy a day in my life. I just feel like my soul is tormented. It's such a strange thing. There are moments when you feel happiness, but at the end of the day, when you look back on it and you ask yourself, *Well, goddamn, nigga, are you happy?* Nine times out of ten, the answer is, *Nah.* That's the thing about being depressed. You don't really know what the root of it is, you just know that you don't feel right about things. And even when things look great to the outside world—the records are selling, the bitches are fucking with you, you've got some money in the bank and you've got your health—something still feels off, and you can't put your finger on it. Even when you can point to a few things that are maybe contributing to you being upset, when you look at those individual things up close and try to put them all together, they don't quite add up to fully explain just how unhappy you feel.

I've also never been able to sleep, not soundly. I'm always thinking. I'm always concerned with the motherfuckers who might be out to get me or the motherfuckers I might have to go at next. I'm always worried about what's coming down the line. And I've never been able to solve it and put it to bed so I can get some sleep. I don't know if I have to make a deal with the devil or what, but that shit wears on you for real.

And it all only got worse as I got older. By the time I was in my

early twenties, my mind was all over the place. I was getting high on painkillers and prescription drugs, taking whatever I could get my hands on, and thinking all types of shit. And I was obsessed with the idea of experiencing dying. That's what I wanted most: to be dead. I was so fucked up, I thought it would be great for my music. I remember thinking, *If I could just die and come back and tell my story, that would be the dopest shit ever. Like, Just imagine the records. How ill would that be?*

I SAW MY FIRST DEAD BODY WHEN I WAS SEVEN, MAYBE EIGHT years old. I was working as a stock boy at a little U-tote-M store around the way. U-tote-M was like a convenience store back in the day. I think they all ended up turning into Circle Ks. Anyway, me and my buddy had been working there trying to pick up a little extra change so we could get some cool toys or whatever, and we were in the back near the freezer one day when some dude comes in with a shotgun looking to rob the place. I guess the cashier didn't give it up fast enough or dude was just trying to make a point, but whatever it was, he blasted that motherfucker right there at the cash register and left him dead in the store. That was some shit. I didn't see him die, but I definitely heard that gun go off. And when we went up to see the body, he was so torn up by that shotgun it was hard to even tell what we were looking at. There was so much blood and guts and flesh and muscle and all of that shit just all mixed up, it didn't even look real.

Well, it didn't take too long for me to see another person dead. I must have been about nine years old when some guy just a couple of streets over from the apartments we were living in shot his old lady in the head. I guess they must have been fighting and she was trying to get away from him or some shit, because he shot her in the apartment and she managed to get outside before she died. And you know how it goes. Someone gets shot in the hood, and the whole block comes out

and starts looking just to see what the hell is going on. By the time I got there, she was already lying on her back dead, with all sorts of shit coming out of her head. The blood was so thick it looked like a deep, deep red corn syrup slowly moving down the street toward the sewer drain. I looked her right in the eyes, and that shit did something to me. After that, I felt something inside of me go numb.

Looking back, I'm amazed at how curious we were back then. Of course, we were kids, so we were interested in almost anything new that was happening, and it wasn't every day that somebody got shot. It was the late seventies and the neighborhood was still pretty intact. Most of the homes had both parents in them. People were working. But once that crack came in, it got to a certain point where you'd hear those shots go off and you didn't even want to go look anymore. You already knew someone was dead. It had become an everyday thing.

That's one thing for sure: the people in Houston don't play. The city is full of stone-cold fucking gunners, I'm talking bodies on record, and that goes for the MCs, too. Like, I know one rapper—I'm not going to say who just because I figure that's his story to tell—but he caught somebody trying to break into one of his trucks, and he shot and killed him right there, dead in the truck. And they had to let him go because he was protecting his property. And I know another cat who found himself in the unfortunate position of trying to break into one of these rapper's homes. He got killed, too. Shot right there in the home.

And cats like Willie D, E.S.G., and 007? These guys are serious business whether they're rapping or not. See, the music was just an outlet for a lot of us. Otherwise, we would have been in the streets. And when you live your life in the streets, death is never too far down the road.

It's no secret that we've seen a lot of death in our town—Fat Pat and

Big Hawk were both killed not too long ago—but I'm not sure that has so much to do with the music scene as it does with just the city itself. The music connection is really just a coincidence. For the most part, our whole town is strapped. And motherfuckers down here are not afraid to let it go.

I remember a buddy of mine, Toast. He was one of my other buddies' little brothers. He was a few years younger than us, but he was a good kid. He was maybe about nineteen at the time, and he was just balling. I tell you what. He had it. He was doing his thing, having his way in high school, fucking with the flyest chicks, and pushing the cleanest rides. I'm talking all elbows and vogues, clean-ass paint job— the whole kit. This kid was so fresh, I think he might have invented rolling up weed in Swisher Sweets. I'd never heard of that shit until he came through and then I put it in "Let Me Roll" and that shit took off. I know for a fact that he was the first one I ever saw with a goddamn TV in his car, that's for damn sure. He was a little-ass nineteen-year-old with a TV in the cleanest Cadillac you ever saw. I mean, wow! He was doing it!

Well, shit, in July of 1992, somebody went in his house and spent the night in there and killed everybody in that motherfucker—Toast, all of his friends, his girl. Everybody. And when they left, they locked the door behind them, too. That's how cold that shit was. It wasn't until we realized that we hadn't heard from Toast in a few days that his brother went to go see about him and found Toast and all of those kids in there, dead. That was a sad, sad day. It fucked me up. It fucked up all of us.

So when I write about death on my records, it's almost never from a rapper's standpoint. I write about what I know, what I experienced, what I thought, or what I saw.

But when you've had the opportunity to see life come into this

world and you've also seen it taken away, you start to look at life a different way. I know I did. Just watching somebody that's getting ready to die who doesn't want to die fight for his life even though he knows there's nothing either one of you can do, and all you can do is just watch him go, like, *Damn.* . . . That's some shit. To look them in the eyes and see life there before it's gone, and then to watch it take off and to see those eyes turn into a blank stare . . . I can't describe it. It's almost like watching a birth. That instant of life and death and creation and destruction—that's the most profound shit in the world. I've seen a lot of people go out. And it's a cold feeling. It will give you a whole new respect for life.

TILL DEATH DO US PART

As fucked up as things were after Willie D left and all through 1992 and early '93, there were two great things that came out of that stretch: N.O. Joe and Mike Dean. Those two guys were key. I can't give them enough credit. I've always had the voice, but those dark and rolling beats that go thump in the trunk and sound like death's either sitting shotgun, pulling up behind you, or posted up around the next corner? That's some shit that me, Bido, Mike, and N.O. Joe (and later Tone Capone) all created together. We all had incredible chemistry, and because of that, we were able to take some of the ideas that I'd been exploring on my earlier records and really develop a true sound. And once we had it, I'd carry it with me for the rest of my career.

I met Mike Dean first. Mike was Bido's partner: Bido brought him in as the engineer for "Street Life," a record we were doing for the soundtrack to the movie *South Central*. I've always liked Mike, but I'll tell you, when I first met him, Mike Dean was a straight-up fucking

cowboy. He was in his early twenties and he was like a damn hippie redneck. Not on some KKK shit. He was more like a redneck stoner, like Willie Nelson, but down to kick it in the hood. He had a pickup truck, long hair, and a shit ton of dogs and guns. He smoked a lot of pot and did a lot of drugs, and he was definitely on one, that's for sure.

He had a beautiful house. I'm talking one of the most beautiful houses in his neighborhood. Marble floors, granite countertops, stainless-steel appliances, chef's knives, amazing furniture, beautiful carpet—the whole deal. But then he also had, like, fifty dogs in that motherfucker, and he'd given them a designated bathroom. Can you believe that shit? A designated bathroom *for the dogs!* So it was a beautiful place, but with all those damn dogs running around, it was also a complete mess. I remember Tone Capone not wanting to even go in there because the place was so beat. But a lot of shit went on in that house. A lot of shit. And shit got heavy. Those are Mike's stories to tell, but just know, he's a real strong dude. Super solid. And he always has been. I loved him as soon as I met him.

There aren't too many people I'd rather make music with than Mike Dean. He's a great fucking guy, and he's a brilliant engineer. But he's not only great at what he does, he's also one of the best team players in the business. I think that's one of the reasons why he's had such a long and successful career. It doesn't really matter what type of shit you're on—you can be going for slow-rolling, shit-talking southern gangster shit or you can be after that crazy, futuristic orchestral shit that he's been doing with Kanye for all of these years—Mike will come in and tighten your shit up. He's just that sick with it. Mike will hear some shit you're working on, hit a few switches, and all of a sudden it'll just be like, *Goddamn, that shit sounds hard!* I'm talking, as soon as he hears it, he'll immediately know what to do with it—whether it's making the beat go backwards at one point, or adding in some

reverb, or doing some whole other shit altogether, but as soon as he's done, it's just like, *Damn, Mike, you're a bad motherfucker!* I'd have Mike Dean mix my shit before anyone else. At the same time, he's also an awesome musician. He can play saxophone, keys, drums, whatever you need. He's really among the elites.

Not too long after I met Mike Dean, I met N.O. Joe. I was in New Orleans with Big Mello, and we were at a Blockbuster Music store, if you remember those. This dude had come up to us and he was like, *You Scarface, nigga? You Face?* And I was like, *Yeah, what's up?* And he said he made beats. Well, I kind of blew it off, like, *Yeah, okay,* and I told Mello to go check out his stuff and let me know if it was any good. Well, Mello goes out to hear something in Joe's car and he comes back inside with his eyes big as hell. He's like, *Man, you need to hear that shit! That nigga's got something. That nigga's got that gumbo funk!* Well, shit, so I went out and Joe played me some beats and he told me had a whole bunch more shit at the house, so we loaded up and headed over there to see what else he was working with.

But the thing was, he was actually trying to rap at the time, and he played me this one record "Rollin' in a Nova," and that shit was hard. I think it actually scared me! Sounded like a six-foot-six motherfucker, just going in: *We used to roll in a motherfucking Nova / Shooting up bitches in the projects that owed ya!*

When I heard that, I was like, *Goddamn, who the fuck is that? Maybe you can introduce me and I can see about signing him.*

And then Joe told me that was him, and I looked at him with his Steve Harvey top and green eyes, and I was like, *Nah, no one's going to believe that shit. Maybe you should stick to making beats.* Ha!

But Joe's shit was dope. It was the hardest, noisiest shit I had ever heard, and it sounded like nothing that had ever been done before. And that was exactly the kind of shit I was looking for. I always wanted

to be working with something that no one else had, and Joe had *that*. His shit was totally different and it was completely original, so I got him to drive from New Orleans to Houston to start working with us on my next album. Of course, once everybody at the label heard the kind of shit he was on, they started putting him on everything. Next thing you know, N.O. Joe is the label's in-house producer. And even though I'd brought him to the table to work with me on my shit, I wasn't tripping. I'm a team player, but it just goes to show, I know what it's supposed to sound like. And when I hear some real talent, I don't fuck around. I go straight for it. Then when Joe plugged up with Mike Dean, that shit was magic. It was pure chaos.

The first album Joe and Mike worked on together was the Geto Boys' 1993 album, *Till Death Do Us Part*. James had brought in Big Mike to take Willie D's spot in the Geto Boys and he'd rented us a beach house in south Texas to work out of, but that album was the last thing I was focused on. I'd just do my shit and then leave. I wasn't trying to hang. I didn't want to be a part of a Geto Boys without Willie D. If we were going to do another Geto Boys album, I wanted the group to be back the way it was. I had no desire to fuck with that album at all.

People always try to make it out like I had some kind of big beef or rivalry with Big Mike during the making of that album, but if you ask me, we never had any problems—not then and not now—at least not in my book. If he ever had a problem with me, then that's his problem, not mine, but I'd known Mike for years—long before he joined the Geto Boys, before he was in the Convicts even. We didn't do a whole gang of songs together in the studio. The way shit went for us back then, we'd all just kind of do our own thing and then J would come through and pick the people he wanted for the album. The majority of the time, I would go into the studio and then Mike would go in, and we'd take those separate sessions and make a song.

But I always thought Mike was dope, and I've never had a problem with someone getting in and doing their thing when they get their moment to shine. That's what you're supposed to do. That's what you need to do. How else are you going to capitalize? Shit. I never worried about Big Mike taking any kind of light off of me. You can't take the light off of me. I'm lit. All you have to do is look at the albums that came after that—*The World Is Yours, The Diary, The Resurrection, The Untouchable, The Fix*—and compare that to whatever else and you'll quickly realize that there isn't a competition and there never was. So I never had a problem with Big Mike. I hope he got his shine and that being a part of that album boosted his career. It ain't every MC that gets a chance to be a part of the Geto Boys. That's some big, epic shit. That's something to run with.

If you ask me, Big Mike is one of the best ever and I really think he doesn't get his due. He's a beast when it comes to spitting rhymes. You ever heard that old saying, *The rhyme did it*? Well, with Big Mike, the rhyme did it. He's a hell of an artist and that first solo album he did, *Still Serious*, is serious as a motherfucker. I don't know what happened to him after that because we kind of lost touch, and whatever Mike had going with whoever he had it going on with ain't have nothing to do with me. (We mind our business down here, and if shit don't pertain to you, then you don't get into it.) But anybody who thinks that I somehow didn't appreciate what Mike brought to the table on *Till Death Do Us Part* has it confused. I didn't have a problem with Mike. I had a problem with the project.

But my next solo album, *The World Is Yours*, was different. I was all in on that album, working with Joe, Bido, and Mike Dean to get my shit tight. Those first couple of Geto Boys albums were a little more unpolished, but once we got to *The World Is Yours*, we had it. From then on, we were dialed in. We had the sound and we didn't let up.

It ain't hard to tell. When you listen to our shit and you listen to all of the other shit coming out of Houston in the eighties and nineties, hell, all the way through the early 2000s, you can just hear how we were on an entirely different playing field from everything else that was going on down here. The rest of the city was in the little leagues while we were in the pros, especially where the production was concerned. Those records are fucking incredible. Once we locked in, we were pumping out some of the most dramatic-sounding shit ever. You can't really compare us to anything else that was coming out of Houston at the time. We were right up there with Dr. Dre and N.W.A and shit like that, really charting a whole new course for rap music as a whole, fuck a region.

And it was all self-taught. Studio time was cheap back then—fifty dollars an hour, max. So we'd go in there and camp out and just figure that shit out through trial and error. You can't really get that experience like that now, not unless you have a big budget to work with or your pockets are super deep. Yeah, you can do a lot more shit on a laptop these days, but it doesn't compare to working on those big boards with studio monitors so you can hear how your shit really sounds. All I know is that as soon as we got in there, we cut loose. We weren't waiting for a lesson or a tutorial or none of that shit. We were ready to go. I know I was. And looking back, for where we came from and what we had, I think we did better than good. We did fucking great.

Honestly, I don't think I get enough credit for my production work. People always want to talk about my pen and my voice, which is great, but I definitely know my way around a studio as well as the page. In fact, I did a lot of the beats for some of my biggest songs— like "I Seen a Man Die," "Hand of the Dead Body," and a bunch of the other records on *The Diary*—in my house, just my uncle Eddie and me. Of course, before the songs were done, we went in and had Mike play a

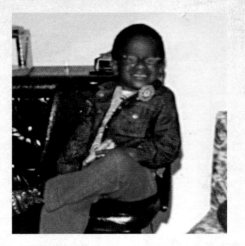

Young Brad at grandma's house.
Courtesy Brad Jordan.

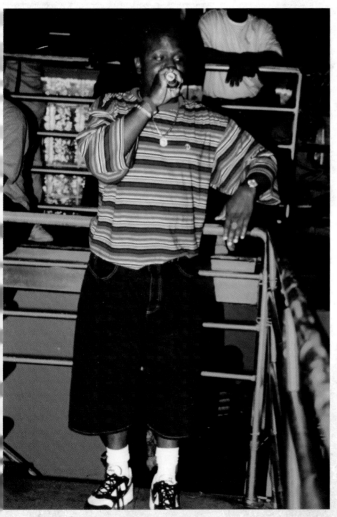

That look was
fashionable back then!
Courtesy Okee Stewart.

BRE Music convention
in New Orleans.
Courtesy Okee Stewart.

Me, Bushwick, and the D.O.C. of N.W.A on tour.
Courtesy Okee Stewart.

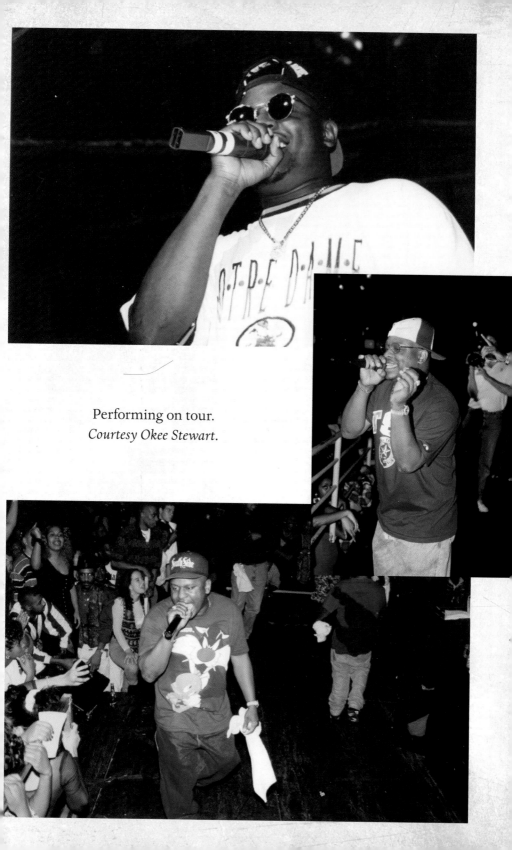

Performing on tour.
Courtesy Okee Stewart.

Outside my maw maw's house in Houston.
Courtesy Okee Stewart.

Uncle Eddie playing bass.
Courtesy Okee Stewart.

Yep. I play this thing.
Courtesy Okee Stewart.

Playing video games at home.
Courtesy Okee Stewart.

On tour with Naughty by Nature and Das EFX.
Courtesy Okee Stewart.

J. Prince rocking that Mr. Scarface shirt.
Courtesy Okee Stewart.

On tour with Naughty by Nature.
Courtesy Okee Stewart.

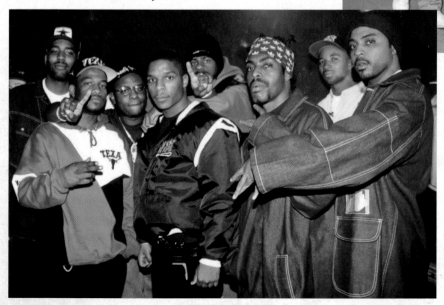

Me and Treach from
Naughty.
Courtesy Brad Jordan.

Me and the Greatest
Entertainer, Doug E. Fresh.
Courtesy Brad Jordan.

Geto Boys and 2 Chainz
at a music festival.
Courtesy Brad Jordan.

Paid a visit to Jay's
office in New York.
Courtesy Brad Jordan.

Me and Nas.
Courtesy Brad Jordan.

Went to see the Doctor.
Courtesy Brad Jordan.

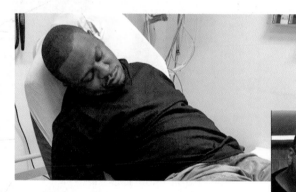

It was just allergies . . .
I got jokes.
Courtesy Brad Jordan.

With De La Soul.
Love these guys!
Courtesy Brad Jordan.

I love the energy in NYC.
Courtesy Brad Jordan.

few chords or Joe take out the drums I'd played on the track and swap them in with his sounds, and then Mike would do his thing in the mix, but the foundation of a lot of my records is all me. I'm talking a lot, a lot. All the way back to "Mind Playing Tricks on Me." That's why I always say, if you put me in a room full of musicians, I'll make you the best album.

I really think I'm as good of a producer as anybody in the game, if not better. Just look at everything I had my hands in from the moment I stepped in the door. I put in a lot of work. I'm talking *a lot* of work. And if anybody wants to say that I didn't get it in, that's bullshit. My discography speaks for itself. I think the only ones close are Dr. Dre, Timbaland, Pharrell, Tone Capone, Mike Dean, and N.O. Joe. That's it. I'm really that bad.

STRICTLY FOR
THE FUNK LOVERS

I always know when I'm about to go into album mode. There's just a certain mood that I get into—a certain vibe. I can just feel that shit. It kind of takes over my body and my emotions and becomes a way of being. It's damn near like going into character because that's what it takes—a full commitment to the process and the message and the words and the whole feel.

To get there, I always start by listening to reggae. It takes me back to my roots and the work my cousin was doing with Bob Marley back in the day. But it's more than the personal ties—it's also the vibe and the substance and the whole mind-set. Albums like Bob Marley's *Legend* and *Natural Mystic* really set the tone and inspire me to think about the shit I want to talk about and the message I want to convey. That's why those records are so dope to me, because every time I sit down, I want to write shit about the system and about being oppressed and being depressed about being oppressed. That's who I am

and that's what I know and that's what's really real. Since the day that I was brought onto this earth, the system has had us fucked up. It holds us down, programs hate, and makes it damn near impossible for us to get up, get out, and get something, and that shit is fucking horrible and depressing—end of story. And reggae speaks directly to that, while still offering hope.

So when I sit down to write, I want to be the voice for every underprivileged kid who feels like there isn't any hope out here. At the same time, I want to let everyone who doesn't know what it feels like to face a lifetime of hopeless bullshit to immediately understand that pain and that anger as soon as they hear my voice and listen to my songs. And I want both of those kids—the one who knows the pain all too well and the other one who's only experienced anything approaching that kind of pain through my music—to know that the shit that I'm putting on my records is the truth. That I know all of this shit firsthand and all too well. That's just how I was raised. I was taught to write your heart, and if you're not crying when the song's done, then you didn't write the right song. And I'll be damned if I don't try to write the right song every time out.

After I've gotten into the right mind-set to write through reggae, I move on to Pink Floyd. I loved KISS growing up, but Pink Floyd is the band that influenced me the most, especially their production. Their shit was just always so out there sonically, especially the work Alan Parsons did on *Dark Side of the Moon*. That's some of the most incredible shit I've ever heard. So when I think about how I want my shit to sound, that's my inspiration. I'm trying to push those same limits, but in my own way.

From there, I start cycling through whatever's current, because I never want to lose my edge. It doesn't matter what's going on in hip-hop—whether it's the hardcore gangsta shit or the fly shit or the

weirdo shit, or whatever it is—I want to make sure I'm up on it and in step, and not so that I can follow the trends, neither. Hell no. I hate all of that copycat shit. Always have. It's always been wack.

Hip-hop has always been about style and self-expression, but it feels like as the culture's gotten older, that's somehow been lost. You've got all of these guys out here now just trying to transform into whatever's hot to chase some dollars and some airplay, but if you're chasing the next man, who the fuck are you really? You get it on the production end, too, but if you ask me, that's not being a producer or an MC, that's being a chameleon. It's biting, straight up. I don't get it. It's fucking up the culture. That shit used to get you clowned out of the game.

I've never tried to make what's popular or tried to jump on some trend to get on the radio and sell records. That shit is corny to me. I'm not trying to make records that are on trend, and I'm not just kicking some raps to catch a check. Never have and never will. I'm trying to make records that are timeless. And that's every time I step in the booth. So when I start diving into current rap, it's not so I can fall in line with what's hot, it's to make sure that I'm not only competitive with the young bucks that are out here getting it, I'm running ahead of the field with the leaders of the pack.

Once I'm caught up with where the game's at today, I take a step back and start breaking out all of the classic shit that raised me and the records made by the people I consider to be my peers. Shit like N.W.A's *100 Miles and Runnin'* and *Niggaz4Life,* Public Enemy's *It Takes a Nation of Millions to Hold Us Back,* A Tribe Called Quest's *Midnight Marauders,* Ice-T's *Power* and all of the Juice Crew shit. No matter how many times I've heard those records, I'm always finding new shit. That's where I get my perspective, because you can't lose sight of that foundation or forget where you came from. Those records really remind me of just how great this art form can truly be. They set the precedent for

making a great hip-hop album and they inspire me to this day. And you can't write if you're not inspired. At least I know I can't. It's never going to work.

I FEEL LIKE I'M ON A MISSION WHEN I'M IN THE BOOTH. LIKE, it's not really about me, it's about bringing everything that's really going on out here to life. I feel like I have a responsibility to do that shit, and that shit is intense.

I think that's why I can't just write a song in a couple of hours. There are guys out here who can just walk in, hear the beat, put the verse down or piece it together in their head, kick that shit, and be out. Now, some of them will just be making a whole lot of noise and not saying shit, but there are others out there that are efficient and stone fucking cold—like Jay Z.

I first met Jay Z in 1998 or 1999 when we were both out in L.A. I was working on my album *The Last of a Dying Breed*, and he came through to lay a few records with me. He was so sick with it and so damn fast that I thought he was spitting prewritten shit. I used to think that was just how he worked—that he had a stash of prewritten rhymes and when it came time to lay something down, he just dipped in that stash and dropped the shit in. It wasn't until a year or so later, after I'd had time to work with him on some more songs like "This Can't Be Life" from *The Dynasty: Roc La Familia* and "Guess Who's Back" from *The Fix*, that I realized he's just a freak of nature. He can hear a beat three times—just sitting there in the studio listening to it ride—and you can be in the middle of a conversation with him, and he'll zero in on something and then jump up and go in the booth and lay that shit down and walk out, like, *So you were saying?* That shit is incredible. I'm not like that at all.

Instead, I'll latch on to a beat that I'm fucking with and let it guide me. I'm like a pit bull with that shit. I'll put the beat on loop and listen

and listen and listen, and maybe jot down some words that I think are cool or sound good or might work well together on a song, and then listen and listen and listen and just not let it go. I'm not about to just walk in and spit a verse just because I have a few lines on a page or in my phone. Nah. I'll take my time, listening, and work out a sixteen-bar verse that feels right and then I'll do it again. Listening, listening, listening, until I work out another sixteen. And I'll just keep going like that until I have the last verse. When I'm really locked in, I try to write at least a song and a half a day. Two songs is a good day. Three songs in a day is almost unheard of. And it's been like that since the beginning.

Because I work so deliberately, I've never been into that whole living-in-the-studio shit. There are a ton of guys out here that that's all they want to do. Pac was like that. Tone Capone and Mike Dean are like that. Dr. Dre is like that. Those guys just live in the lab. But not me. My baseline goal has always been one song a day, every day, even if it's just a beat or even one verse. Just put that consistent, quality work in, and if I've got something down that I like and feels solid, then go do something else. But, shit, guys like Pac? Pac would do five or six songs in one day, minimum! His work ethic was stone cold, colder than anybody else's I've ever seen. It's something to aspire to, especially when you're booking time in a big studio that you don't own. When you're putting that kind of bread on the table, it's all about pushing yourself to get as many songs done as possible, whatever it takes. We recorded like that in the very early days, but as soon as I could break free of that crunch, I did.

But recording with Pac was some shit. You had to be ready with your verse in thirty minutes or less because he was already ready to go. And if you weren't ready by the time he was ready to record, he'd give you shit like you were bullshitting. I remember one night we were working together and I was sitting at the board writing when Pac came in with his shit all sewn up, like, *You ready?*

And I was like, *Man, I gotta finish this song. They're telling me I've got to get a single.*

And he just blew up.

Man, you're sitting here all fucking day and all fucking night trying to get a single! You're not going to get a single, just write that shit! Just keeping writing!

See, his whole thing was rather than try to make the perfect record, just keep making records, and the right record would come out of the work and that's how you'd get your single. He used to always say, *You're gonna make a motherfucker think, or you're going to make a motherfucker dance.* I was trying to make motherfuckers think, and I know he was, too. But he was also after the other thing. And he had a trick. *You have to get across to these bitches without offending them, and then the niggas are going to want what the bitches want,* he told me. Well, shit, he had a gift for both. That's why he had so many great records, and in such a short time, too.

I REALLY THINK THE MOST IMPORTANT PART OF THE SONG IS the first four or five lines that you hear. Those are the come lines—the bars that are going to draw you in, set the mood, and let you know what the song is going to be about and whether you should be fucking with it or not. Shit like *Now the funeral is over / And all the tears have dried up,* from "No Tears," or *He greets his father with his hands out / Rehabilitated slightly, glad to be the man's child* from "I Seen a Man Die." I pride myself on my come lines and I always put the most time into those. I want you to know as soon as you hear my voice: you should always be fucking with my records.

At the same time, I'm super critical of my own shit. You have no idea. Making music is what I do. It's my only hustle. I don't own a beauty salon or a detail shop or a Wing Stop or none of that shit. I

make music, and it's consumed the majority of my adult life to the point where I never really had time for anything else. It's only recently that I've started getting out and coaching football and playing golf, but really, ever since I was sixteen, I've been in the studio recording my life, trying to make the best music I can make, to live up to my family's legacy, and to be a part of history. I've always felt like I've had something to prove, and that's still true to this day and will probably be true until the day I die.

But it's because of that drive and that competitiveness that I never listen to my own songs. Never. I can't. I listen to the songs when I'm recording them and we're working on them, of course, but once it's done, I'm done. I feel like I put so much into it that I don't want to hear it anymore. You know, once it's out, you've already tinkered with it so much and worked so hard to perfect the mix or get the vocals or the drums just right or tighten up a verse or whatever it is, once it's released into the world, that's it. You can't touch it up or improve it anymore, so anything you hear on that commercial version that you might want to do differently, or worse, any imperfections you might hear (even if it's something only you can hear because it's buried so deep in the mix), that's it. It's done. It's outta here. And I don't need all of that drama because I know ten times out of ten, I'm going to hear some shit that we could have made hit just a bit harder or done just a bit better. So I just avoid it altogether. When it's done—or at least when the label tells me it's done, because I will work on an album for damn near ten years if someone didn't make me stop—then I don't want any part of it.

To me, making music is kind of like being with a woman in that way. When you're writing the songs and making the beats, it's like you're in love with her, but as soon as you're done, it's like you've had her, the passion's gone, and that's it. You don't even want to be around her anymore and it's on to the next one.

CHAPTER 21

THE DIARY

I never actually kept a diary. Crazy, right? I put out all of these songs about it, and even an album, but I never actually kept one for myself. The closest that I ever came to keeping one was my rhyme book. I wrote songs about what I saw and what I felt and just put everything that happened into my music. That's where I wrote my life.

Till Death Do Us Part and *The World Is Yours* both went gold, but as much as I liked *The World Is Yours* (and as much as I didn't fuck with *Till Death Do Us Part*), neither one had the same impact as *We Can't Be Stopped* or *Mr. Scarface Is Back*. There was room to grow. It was 1994, and I was ready to get to work.

All I knew when we started recording *The Diary* was that I wanteded to combine the hardness and the roughness of *Mr. Scarface Is Back* with the production that we'd figured out on *The World Is Yours*. That was it. We never went into an album with a plan. There was never a moment where we sat down and said, *This album is going to be this,*

this, and this, and it's going to fuck motherfuckers' heads up for real! It was never like that with us. We just knew I was cold, N.O. Joe and Mike Dean and my uncle Eddie were cold, and all of the musicians that we brought in to work with us were bad motherfuckers. I'd get fucked up and record and see what came of it and then take that and see what we could do with it.

I had just bought my first house. I was twenty-three and it was over in a neighborhood called Woodlands. Real estate was still pretty inexpensive and I got a 3,500-square-foot house for around $200,000. This was before Woodlands took off. I ended up selling it a few years later for $400,000 and I hadn't done shit to it but put a studio in it. Considering how much money I was able to make on that deal, I don't know why I didn't just go into real estate back then. The white folks that bought it off of me didn't know shit about making music so it wasn't like they were buying it for the studio and I still made some good bread.

Once I had the studio up and running, we started doing a lot of preproduction work there, and then we'd move over to Digital Services to record with John Moran. John's worked with everyone from the Rolling Stones and the Talking Heads to ZZ Top, Willie Nelson, and INXS—you name it. We'd worked with him a lot on the early Rap-A-Lot stuff and he's a fucking genius when it comes to mixing and mastering. He can get the most incredible sounds out of records, and I knew with him in our corner, the shit we were working on was going to be super tight.

Well, shit, one day early in the process, I was at Digital Services with N.O. Joe just bullshitting. And I don't know if something set me off or if I was just drunk or high (or both) and just fucking around, but whatever it was, I hit a wood wall in that motherfucker and broke my goddamn hand. I think I hit harder than my bones can take, because I used to break my hand all of the time—fucking around, fighting

motherfuckers, or just doing stupid shit—and I'd done it again. I recorded the rest of the album with my hand in a cast, popping painkillers, drinking Miller Lites, and smoking weed, just sky fucking high. I'm talking really, really, really high. But I'll tell you what—weed, beer, and painkillers make the best music. And in that case, we fucked around and made a fucking classic.

That album was my *Dark Side of the Moon*. Just like Pink Floyd had already made noise with those creepy-ass albums that came before it—*Ummagumma, Relics, Meddle,* and shit like that—*Mr. Scarface Is Back, The World Is Yours,* and all of the Geto Boys shit had gotten me some respect and attention. But just like *Dark Side of the Moon* carved its own legacy, almost independent of the group, and is seen as the album that really put Pink Floyd in the rock and roll history books, *The Diary* changed my life as an artist.

Really, I've got to give it up to N.O. Joe. He brought me a new sound—this funky swing with really heavy, noisy drums. And then I was able to go in and add my melodies and bass lines, with Mike coming on top of it with all of these chords, and together we were able to create a whole new platform that gave my shit a new, unique sound to build on and expand and contract around. It was Joe's noise, Mike's chords, and my melodies with my uncle Eddie on the bass that really gave *The Diary* its feel. And just like Alan Parsons was able to take Pink Floyd and give them a depth and a polish on *Dark Side* that they'd never had before, Mike, Joe, Eddie, and I were able to take the hothead that I'd been on the earlier projects and distill that down to its core.

The Diary was deeper and broader than anything I'd done before, and wiser, too. Instead of just popping off on every song, we took the darkness, awareness, and torment of records like "Mind Playing Tricks" and "Diary of a Madman" and stretched that across a whole album. It was extremely personal and extremely relatable at the same time, and it was nothing like hip-hop had ever heard before. It also

sounded incredible. I'll always remember one of Dr. Dre's engineers telling me that Dre kept a copy of *The Diary* in the studio as a reference for how sick some shit could sound. It was that good.

I REMEMBER MAKING THE ORIGINAL BEAT FOR "I SEEN A MAN Die" at my house. Then Mike came in and added the organs and the horns and Bido took out my drums and added in his, and I rode around for weeks and weeks listening to that beat because I couldn't think of anything to put to it. One night, I took a painkiller, cracked open a 40 of Miller Lite, smoked a joint, and just started writing. I was so fucking high that I was losing my shit, and I remember laying on the floor and making promises to God, like, *Lord, if you let me come down off of this high, I promise I won't get high like this anymore.* When I woke up the next day, I didn't even know what I'd written until I went to the studio to cut the vocals. I smoked a joint and hit the lights so it was dark as shit and all I could smell was that good-ass weed, and I went in the booth and did my thing. When I came out and played it back, I wasn't sure if I was just high or if what I was thinking was true, but my first thought when I heard the record with my verses on it was, *This is some groundbreaking shit!* Well, when I listened to it again a couple of days later and it still sounded dope, I knew that when people got ahold of it, it was going to be something special. And it was.

"I Seen a Man Die" was a huge record for me. We released it as the album's second single ("Hand of the Dead Body," with Ice Cube and Devin the Dude, had been the first), but we had to retitle it because Virgin Records was tripping. James had signed a big new distribution deal for Rap-A-Lot with Virgin in August, and *The Diary* was the first album we were putting out with Virgin behind us. Virgin was a huge pop and rock label at the time—they had Janet Jackson and Smashing Pumpkins and shit like that—and they wanted us to help them

gain a position in hip-hop. Of course, I didn't see shit from that deal personally. I just knew I was on the same label as Janet Jackson, so that seemed like a good look.

The Diary came out on October 18, 1994, and Virgin didn't want anything associating us with death going to radio, so "Hand of the Dead Body" became "People Don't Believe" and "I Seen a Man Die" became "Never Seen a Man Cry." Whatever. That shit was crazy to me, but the name changes definitely didn't slow those records down.

"Hand of the Dead Body" came first. I'd met Devin the Dude when he was at Digital Services with the Odd Squad playing some of the records off of their first album, *Fadanuf Fa Erybody!!* I thought that shit was dope! It's just so original. While everybody else was talking all of that hardcore gangsta shit, Devin and the Odd Squad came through and made an album that was funny as fuck with dope-ass beats and rhymes right in the pocket. To this day, I still think that first Odd Squad album is one of the best albums Rap-A-Lot ever put out.

After the Odd Squad album came out, Devin was just sitting around, chilling, so I asked him to come be in the Mob, which was a group of guys I'd started putting together—DMG, Chi-Ray, 350, Smit-D—who were straight raw. I always thought Devin was dope. And he's a great artist. I'm talking big-time. He's by far one of the most fun people to work with in the studio. Though he also might be the slowest motherfucker when it comes to making a record. He's worse than me with that shit. He could get started on an album next week and that thing won't be finished for another five years. But one of the things that I've always loved about Devin is that it doesn't matter with him—whether he's dirt-poor or filthy rich, he's always the same dude. What a guy. And of course, I'd been a fan of Cube since I was first coming up in the game.

"Hand of the Dead Body" wasn't a runaway hit, but it was an im-

portant record to me and for the culture. Hip-hop was always getting caught up in so much bullshit in the courts and in the media, and I'd already been blamed for two deaths—one in Kansas and the other in Texas—that I'd had absolutely nothing to do with just because the guys who pulled the trigger had been listening to my music at some point during the night they decided to take a life. So this song was an opportunity to take aim and fire back at that pattern of casting blame and censoring us. (That Virgin made us change the name of the song before we went to radio only drove home the point.) Let's be real: these crooked-ass cops beat the shit out of us and shoot us with little to no provocation, but then when we bust back it's a problem? Like I say on that record, *David Duke's got a shotgun / So why you get upset 'cause I've got one?* I never got it. It's an incredibly one-sided power dynamic, and this song was an attempt to paint the picture of what it's like when you're on the other side of the oppressor's gun.

But as important as "Hand of the Dead Body" was, "I Seen a Man Die" was special. That record touched everything. It was my first Top 40 hit as a solo artist, and as big as "Mind Playing Tricks on Me" had been, "I Seen a Man Die" was the record that really broke me in New York. It finally didn't matter where I was from. People all over accepted the record as their own.

The success of "I Seen a Man Die" changed the way rap artists started approaching their songs. Everybody was still talking about how dope of an MC they were, but after that reality hit—and hit big—things changed. It really made everyone think about what kind of thoughts and messages could be worked into a song, and it showed what can be done when you explore emotions that are that raw. It also forced people to understand what can happen when you use your voice as an instrument. I wasn't the first one to do that, of course. Biz Markie has one of the greatest and most versatile voices of all time,

and you can't be a successful MC without a unique voice. But "I Seen a Man Die" really shifted the culture away from motherfuckers leaning so hard on the monotone delivery and into trying to work more of a range into their songs.

And then it was also all true. I've seen men die. I've seen people decapitated from auto accidents and cars on the freeway, mashed with bodies hanging out the window. I've seen babies stuffed in pillowcases, tossed out and forgotten, and dudes sitting in their cars all engulfed in flames until there's nothing but ash. I watched the dope wars rip through our neighborhood when I was a kid and the Colombians brutalize and terrorize their rivals in some of the most horrific ways. And I took a look at that war zone as a young teen, and I hopped right in.

It'd be easy for me to blame the depression that I've experienced since I was young on all of the shit that I saw as a kid, but I have to believe that I wouldn't have seen it if it hadn't been meant for me to see. It was those experiences and those visions, plus all of the darkness and the drugs and the depression that I've battled all of my life, that set me up to make "I Seen a Man Die," a record that not only did incredible things for my career, it touched motherfuckers' lives. And that's real power. Not my power, but the power of the art and the music that I was put here to participate in, create, and mold. If I had lived a happier life, those lives would have never been touched because that record—that whole album—would have never been made. And that's real shit.

PART FOUR

THE GOOD,
THE BAD &
THE UGLY

THE RESURRECTION

From the moment I signed my first deal I never stopped making music. I was just always doing something, whether it was making beats, writing songs, writing raps for Bill or some other artist, whatever it was. I was always fucking with something. It's right there on record. When you look at my career and you really see just how much music I had my hands in over the years, it ain't too hard to tell what I was doing with my time. Just think, we released four albums between 1989 and 1991. *Four!* Sure, one of them was Rick Rubin's reworking of the *Grip It!* album, but still, that's a lot of fucking music.

And none of it was mass-produced or just slapped together to get something out in the market neither. Those albums defined an era and carved out a lane for an entire region. Shit, by the time *Mr. Scarface Is Back* came out in October 1991, we'd already established a Rap-A-Lot legacy. Just think about it. If it had all gone south then and Rap-A-Lot had never put out another album after my solo debut, we'd still be

talking about Rap-A-Lot today. But of course, *Mr. Scarface Is Back* was just the beginning. We were just getting warmed up.

The Diary was a huge success. It came out in late October 1994 and debuted at number two—I'm not talking about the rap chart, either, I'm talking the big *Billboard* chart—just behind Kenny G. It was certified platinum before Christmas. Riding high, I started spending more and more time in L.A., going back and forth between Texas and California, working and really, maybe for the first time, just loving life. My solo shit had popped, and L.A. had embraced me almost like I was one of the city's own. I loved it out there. I was twenty-four years old and I was working with some of the best with access to some of the best studios in the world. I was taking full advantage and getting my production work *off*.

At the time, I was working on a lot of records at once, just getting it in. I'd go into the studio, get busy, and knock out two or three complete songs a day without even thinking about what project they were going on. If the songs got placed on an album, they got placed, but if they didn't, I wasn't sweating it. All I'd ever wanted to do was make music, and that's all anybody wanted me to do. I was living my dream.

There was never a moment where we sat down and said, *We're going to make another Geto Boys album*. I was in L.A. working on finishing the first Facemob album, *The Other Side of the Law*. DMG and Chi-Ray had come up with the name Facemob, and after we'd done a few songs together they let me know they wanted to do a group album. I was down. I liked working with those guys and I knew I'd get to produce. It was a cool little project.

While working on the Facemob album, I started doing some records with DMG (including "Open Minded," which eventually ended up on *The Resurrection*), and there started to be some talk about possi-

bly doing another Geto Boys album. At one point, it looked like DMG might be in the group, either to replace Big Mike or Willie D or both. And then Big Mike's name came back up in the mix.

But I drew a line. The only way I was going to agree to record another Geto Boys album was if Willie D came back to the group. That was a big sticking point to me. *Till Death Do Us Part* had gone gold and there were some big records on there, but I always thought the chemistry that Willie, Bill, and I had produced the best work. We'd spent a lot of time together doing records and on the road. We knew what worked and we knew how to make it click. And I was only interested in doing great work. I had a name and a growing legacy to protect. I felt like I'd earned that right.

It's not like we'd broken up over beef anyway. Bill was a wild man and we all had our own ways of doing things, but the group never had any real problems. It was the business that had fucked us up. I'm not saying I made the reunion happen—James and Willie had to work their own shit out—but once they hooked up and the business got squared away, Willie was back in the group.

The news energized me. Big Mike was dope, but I always liked how Willie and me bounced off of each other on record. We really brought two different identities to the studio, and we had great chemistry. I knew having him back in the group was going to be a great thing, and I was ready to get to work.

Up until that point, I'd always been pretty distant from the Geto Boys' albums. I was down to contribute, but those group projects weren't really my focus. Like I said, I didn't really know those dudes, at least not like that, so I wasn't really trying to hang too tough. I was much more interested in working on my solo shit. But that changed with *The Resurrection*, and I became much more engaged. Instead of checking in and checking out, I took the momentum I had coming

off the Facemob project and the boost I got from knowing Willie was back in the group and ended up producing about 70 to 80 percent of the album myself. (In the end, the Geto Boys project put Facemob on the back burner, and *The Other Side of the Law* didn't come out until nearly a year later, well after *The Resurrection* was in stores.)

We recorded the album in Houston and finished it in California because I just really wanted to be in L.A. And even though the group was back together, the process was the same. Willie and I would write for Bill, we'd all come in and do our parts separately, and then we'd break out. It was great having everyone back in the group, but that didn't mean that we needed to hang.

The open caskets on the album cover were my idea. James always trusted my vision for certain shit, like album art. (It probably didn't hurt that my uncle Rodney had drawn the cover for *The Diary* and that album had been a huge success.) The way I saw it, we'd been dead and buried. They'd written us off. Close the caskets, the Geto Boys were done. But that wasn't the case at all—we weren't dead, we'd risen. We'd been resurrected. And then J decided to break out the big guns to mark the occasion.

I HAD NO IDEA LARRY HOOVER WAS GOING TO BE ON THE AL-bum until he was on that motherfucker and the album was done. That was all James. I wasn't there and I didn't know a conversation was taking place or even in the works. We really didn't do too much talking about shit like that. It was all very quiet. We all knew what it was. So by the time James and Larry Hoover had talked and we had a recording of their conversation, we just put it on the album. It wasn't like we had a big meeting about it. If James had some shit that had to go on the album, it was going on that motherfucker whether you wanted it there or not. It wasn't a discussion. He wasn't bullying us. His whole

thing was, *This is what's best for us right now. This is what's best for the team.* It wasn't about I, I, I, or me, me, me. It was just, *This is not only better for me, but it's better for* us.

And it was. It was a huge fucking deal, a real great moment in rap history. But that's just the wave that James was on, even way back then. J's a genius for putting together those kind of power moves that will draw attention to us and help generate buzz and controversy. He knew that making that call and getting Larry Hoover's voice on tape and then putting it on the record would be the type of shit that would make the whole world have to sit up, take note, and tune in.

You've got to understand, Larry Hoover is probably one of the most powerful men in America behind the president. A lot of people follow Larry Hoover. I'm talking *a lot.* And the majority of them have never even heard his voice because the country views him as such a big threat that he's been in jail since I was a child. And J put that together. James was in the position to make that call happen in 1995–1996.

That just goes to show you how powerful J is, too, because Larry Hoover ain't no play toy. That's a solid dude right there. Real solid. He's really, *really* real. And if you really think about how powerful Larry Hoover is and then you realize everything that must have gone into not only making that call happen, but then getting that call on the album, then that will let you know what light you should see James in.

I think a lot of people misunderstand Larry Hoover's mission, and that's why they feel like he's a threat. And I think the same thing goes for James—a lot of people misunderstand his mission and that's why they see *him* as a threat, too. But any two ways you look at it, when you've got Larry Hoover and James Prince on the phone, you've got two incredibly smart black men with massive followings and massive power coming together on one call. And you've got to respect

it. You've got to. Of course the powers that be aren't going to want to hear that shit. They've got no interest in those two guys coming together to talk about resurrecting our people, waking our people up, providing them with jobs to help make them functioning individuals in this society. I can only imagine how many federal agencies were tapped into that call.

Believe it or not, James hired all of his buddies when they got out of jail. I'm talking convicted felons with a much better shot at catching another case just walking down the street than finding a minimum-wage job, no matter how many doors they knock on. And James put them to work. After they paid their debt to society, he gave them all jobs and helped them feed their families by giving them something to do in a positive environment that would keep them from falling back into that motherfucking cage. And the powers that be don't want to see that. They never have. And that's why they were always on our ass at Rap-A-Lot, and that's the same reason they were always on Larry Hoover and his people, too. When they see us out here getting it, they'll do anything they can to pull us down and set us up so that they can put an end to our success once and for all.

Looking back on it now, all I can say is, *Goddamn, J was making moves!* That's a smart, brilliant-ass dude who stayed bossed up and fifty steps ahead of every fucking thing. I'm talking light-years ahead of everyone. I'm in my forties now and I'm just now grasping the concepts that James was pushing when he was in his twenties.

You want to talk about reality rap or gangsta rap or whatever you want to call it? We used the platform of our music to bring the voice of a ghetto prisoner to the streets of the world. We made it so his family and his friends and all of his followers who couldn't hear from him anymore, or had never heard his voice, could hear him talk that real shit about uplifting the youth and getting out the vote and making a

positive change in these young people's lives. The Geto Boys did that. And it was a beautiful thing.

The Resurrection came out on March 19, 1996, and the fans and the critics loved it. It was the Geto Boys' first album to break *Billboard's* top ten (*Till Death Do Us Part* had debuted at number eleven). In the end, it didn't sell quite as well as *We Can't Be Stopped* (*The Resurrection* topped out at gold), but its impact couldn't be denied. Years later, I saw something where Chris Rock said he thought the album was one of the top twenty-five best hip-hop albums of all time. I think the album is phenomenal. Some may disagree, but in my opinion it's the best Geto Boys album we ever made.

SMILE

I built my first house while we were in Houston recording *The Resurrection*, and I loved it. The process, the house, the whole shit. I'd just turned twenty-five, but even though I had a new home in my hometown, I felt like my life was in L.A. Whenever I was in Texas, I was always in a hurry to get back to the West Coast.

I was living at the CBS Apartments on Beverly Boulevard and working out of Enterprise Studios. Mike Dean was doing a lot of work out there, too, and we'd hook up, hit the studio with a shit ton of drugs, and see what we could create. I was focused on Facemob and *The Resurrection*, but Mike was touching everything, mixing down damn near every release that was coming through Rap-A-Lot at the time. And that's how we met Tone Capone.

Tone Capone was a producer from Oakland who blew the fuck up after he produced "I Got 5 on It" for a local group he'd been fucking with, Luniz. That record was huge. I'm talking "Mind Playing Tricks

on Me" huge, but even bigger than that. "Mind Playing Tricks on Me" broke the top twenty-five. "I Got 5 on It" went top ten and platinum as a single. By late 1995, Tone was in demand. Everyone wanted him to make them another "I Got 5 on It"–type hit.

Back in the early 90s, Rap-A-Lot had picked up this dude from the Bay, Seagram. We'd put out a couple of albums on him, but even though he'd made some noise, he hadn't really popped. So in late '95, Seagram hooked up with Tone to cut some records for his third album, *Souls on Ice*. They recorded in Houston and then Tone flew out to L.A. to work with Mike Dean on the mix. I guess Mike liked what he heard, because he brought Tone in to work with us. It was a great call on Mike's part because Tone Capone was no joke. *The Diary* had been me, Mike Dean, and Joe. But now, in Tone, we had another stone cold motherfucker on the team. The best chemistry I've ever had in the studio was with Mike Dean, N.O. Joe, and Tone Capone. Tone's got a real raw, live musician funk to his sound, and he was real in the pocket with it. His shit was a bit harder and more direct than some of the shit we'd been fucking with before, and when you put us all together, that shit was mean as a motherfucker. It was extra crisp and too, too raw.

There wasn't a grand plan or strategy heading into a new album. The mind-set was just, *Get in the studio and work.* We'd figure out what we had after we had it. So I'd just show up with what I always brought to the table—an unyielding commitment to block out the bullshit, provoke thought, and just do me—and we'd go from there. That was always my thing: never compromise the integrity of the craft.

We started working on *The Untouchable* in early '96. I was smoking a whole lot of weed and doing a lot of drugs. I'm talking *a lot* of drugs. I think of that album as my weed-and-Ecstasy album because I wrote the whole thing high on weed and recorded everything while I was

rolling on X. Ecstasy was just starting to become common then, and you were just starting to see motherfuckers walking around Xed out with their jaws clenched tight as shit. Mike had gotten into it and he started telling us about it, and shit, we didn't think twice. We just wanted to get high.

But I'll tell you, that feeling of euphoria that Ecstasy gives you is really something else. It's just a beautiful, nice and clean high, and no matter what you were doing when you did it, when you were on X, you were going to do that thing five hundred million times better and that's all you were going to want to do. So if you were recording when it kicked in, you weren't about to leave the studio. You were going to sit there making music for hours, experimenting with shit until you found that one incredible sound that you couldn't let go. Just listen to "Faith." That's some spacey shit right there.

I remember writing "Mary Jane" one night at my mom's house in Houston. It was dark and I was lying on the floor listening to the Commodores' "Say Yeah" in my headphones while my mama was asleep with the TV on. And I wrote the song to that. The original hook was "Say Yeah" and everything. Well, when I hooked back up with Tone, he had a beat he was fucking with for a record we were thinking about called "Project Hoe." It was kind of a twist on Rick James's "Mary Jane" and it was playing in the other room. We were fucking around with "Say Yeah" and I rapped the *Mary, Mary* on top of it and I guess a light went on for Tone because he brought me into the room where the "Project Hoe" beat was playing and was like, *Do that shit again.* So I did, and I told him I thought it sounded off beat, but Tone was convinced. He'd always thought of the "Project Hoe" beat as more of a weed record anyway, so I guess he'd found what he wanted because it didn't matter what I said, he wasn't hearing it. He was like, *No, it's right, bro. It's right. Trust me.*

Tone had the bass and the drums down and then Mike came in and added in the harps and the organ. And then Tone went back on top of that and fleshed it out with the string melody, and the record was done. And that's how we recorded *The Untouchable* for the most part—just a whole lot of collaboration. Tone and I would get something started or Mike and I would get something started, or I'd just start fucking with some shit on my own, and then we'd all hook up and fuck with it, add some extra layers, and bring it home.

And sometimes it was just about taking shit out, too. Like, I remember when we were recording "Southside," Tone had built the foundation of that beat—laid the groove and the drums—and Mike went on top of it and added a bunch of shit to it, but I decided to pull it all back out because I thought it sounded tougher leaner and a bit more straight-ahead. Years later, Tone told me that he ran into Jay Z in New York and Jay rapped my whole "Southside" verse to him a cappella just because he was fucking with it that hard. Can you believe that shit? I wasn't there, but still. And just think, when I was first starting out, we were struggling to get love in New York.

But of course the big record on *The Untouchable* was "Smile." That was the song that drove that album to the top of the charts.

I FIRST GOT TO KNOW TUPAC IN 1991. WE DID SOME RECORDS together along the way, but I probably spent more time with him on the road than in the studio, and over the years we really developed a close, personal relationship. We were partners more than we were collaborators, so we were never tripping off of making songs together. We were friends and we knew the music would figure itself out. We'd been together back in the early days when we were all underdogs—him, me, Too $hort, Spice-1, MC Breed, Richie Rich, the D.O.C. In 1991, '92, '93 and shit like that. Nobody believed in us. We were young

and from outside of New York and on that reality shit. We had record deals and we had our fans, but nobody fucked with us like *that*. They definitely didn't expect us to make it big. But then all of a sudden, it was like, *bam!* We were fucking huge. I'm talking number-one albums, Top 40 hits, the whole shit. We'd struggled together, fighting for that success, side by side. We were there when the D.O.C. lost his voice, the whole shit. And then when motherfuckers started blowing up in '93 and '94, it was like, *Damn, we did it!* You know?

But it goes without saying that Pac was special. Not only did he have the coldest work ethic ever, he was just straight up off the chain at all times. Like, we learned real quick that you didn't ride with Pac. If you were going out with him, you always took your own car because that motherfucker was reckless. He did not give a fuck, for real. It didn't matter where he was—onstage, behind the wheel, just walking down the street or at a restaurant or a hotel lobby, whatever. He was a loose cannon. He was the kind of kid that you want on your football team because he didn't think twice about anything and he wasn't scared of shit. You could be ten times his size, and if he had a problem with you, he was going to let it be known, like, *Fuck it!* You had to respect him, but at the same time you'd just watch him do shit like, *Damn, that motherfucker is crazy!*

I remember one time we were on the road together getting show money running all through the Midwest. This was in the *Strictly 4 My N.I.G.G.A.Z.* and *2Pacalypse Now* days, before he put out *Me Against the World* and all of that shit. We were in Minnesota and he was opening up for us. I don't know what it was, but the crowd was rowdy as a motherfucker that night, throwing shit at the stage, starting fights, you name it. And Pac wasn't having it, so in the middle of his set he tells the crowd, *Next motherfucker that throws something up on this stage, I'm going to bust their motherfucking mouth. Better yet . . .* And then he

goes into a bag he's got stashed at the back of the stage and brings out the guns. Man, shit, as soon as he did that, that motherfucker emptied out so quick, the whole crowd was ghost.

I had to pull him aside when he came backstage, like, *Homeboy, what the fuck did you go and do that for? You fucked up our money. They're not going to pay me because we didn't have a chance to perform.*

And you bet your ass, after that bullshit we switched up the order of the sets so we could do our thing before he got out there and did whatever the fuck he was going to do. I wasn't about to lose another check just because he had a problem with someone in the crowd and got to fighting. Fuck that.

Of course, the very next night we're in Milwaukee and he got into some shit either at the show or at the club after the show, and next thing you know, it seems like the whole goddamn city is in the lobby of the hotel looking to tear shit up. I have no idea what got into them, but we're all upstairs while motherfuckers are down there busting out windows and breaking shit. And Pac comes barreling into my room, like, *Let's go see those motherfuckers!* He wasn't trying to have anybody come up and try to intimidate him or threaten him or none of that shit. He didn't care that we were in Milwaukee and we had us and they had their whole town.

I was like, *Man, are you crazy? You better sit your motherfucking ass down. Them niggas are down there shooting.*

But that's just how it was with him. That was Pac. And we were there for each other through thick and thin. Thick and thin. That's one of the reasons why we didn't hang out super tough all of the time. The way he was and the way I am, he would have been out there getting into all sorts of shit, which would have led to me fighting all sorts of motherfuckers all the time because the way our relationship was, if he was going to get into it, then I was going to have to get into it, too. If

motherfuckers were going to start shooting, then I was going to have to start shooting, too. We were going to do all of that shit together.

I just happened to never be around when the shit really went down. Like, when he got shot at Quad Studios in Times Square, I was across the street, upstairs at the DoubleTree. If I had known that he was in trouble, we would have both gotten shot or those motherfuckers would have been dead, one of the two. Same thing with the night he got killed. I'd just been with him in L.A. recording "Smile." Then he went to Vegas for the fight and got shot on the Strip. That shit fucked me up.

THE NIGHT WE RECORDED "SMILE," A BUDDY OF MINE HAD been standing outside on Sunset Boulevard when Pac drove by with Eddie Griffin. They saw him, busted a U-Turn, and said we should come meet them at the Hilton. So we walked over there to have a few drinks and after a while, Pac was like, *I'm going to come pick you up to do this record*. I told him I was with it, so he cut out and we went down the street to chill for a bit. We're hanging out, and then this motherfucker pulls up in a black Hummer with all kind of sirens and shit on it. And he hits that loudspeaker like, *Brad Jordan, come out with your hands up!*

Man, shit. I'd been smoking that good L.A. weed, too, so I didn't know what the fuck was going on. I turned to one of my boys, like, *Yo, what the fuck did I do?* My man was like, *Don't trip, I've got you*. And we head downstairs and it's Pac in this fucking commando Hummer. That motherfucker had me going, too. He wanted to go to the studio, but of course, I wasn't about to go anywhere with his ass. I never knew who kept giving him cars. I thought everybody knew that motherfucker couldn't drive.

I got my own ride and met him over there. We jammed like a motherfucker and ended up laying down "Smile." That was the last time I ever saw him.

I was in the middle of the fucking desert on the way back to Houston when I got that call that Pac had been shot. I got the news and sighed, like, *Again?* It wasn't like it was the first time it had happened. He was always getting into something. It had gotten to the point that when you got news like that about him, you almost didn't even think about it. It was fucked up for sure. Nobody wants to get shot or wants to hear about their people getting shot. But you kind of just knew he was going to make it. He was Pac! It had started to seem like he was damn near invincible with all of the shit he was always getting into and all of the stories he lived to tell.

Shit, when I first got the news he'd been shot, my first thought wasn't *Oh, shit, what happened?* It was, *Shit, Pac's really about to be loose now!* You know, Pac wasn't the kind of guy you wanted to shoot and then have him back out there on the streets. I just knew he was going to be all right and he was going to be even more wild once he recovered. I just knew it. So I was concerned, but I was certain he was going to pull through. He always did.

And then he didn't, and seven days later, on September 13, he was dead. I was in Houston when I got the call that he had died. *That can't be true,* I thought. *It has to be a rumor. No way Pac is just going to die like that.* I just couldn't believe he was gone.

This was 1996 and still in the early days of the Internet, but when they released the autopsy, I looked it up online. Seeing my friend lying there all cut up, cold, and dead blew me away. I flipped out and just started screaming, *What the fuck did you do?!* It hurt me so much to see him like that—with his guts all open and the bullet wounds marked with sticks—it probably would have been better if I had never seen those photos.

I've seen a whole lot of crazy shit in my time, but seeing autopsy pictures of your friends is a whole different thing. (After my childhood

friend Smitty was killed, I saw his autopsy pictures, too.) I hope I never have to see some shit like that again. But as soon as I saw those photos, I knew he was gone. I'd lost my friend and he was never coming back. He was a great guy and he was still so young—just twenty-six years old. I've got kids as old as he was when he was killed. I really miss him. Losing him broke my heart.

After Pac died, we went back in the studio to finish "Smile." Tone rearranged the hook a bit and then we polished up the beat and the mix. Stevie Wonder was working in the studio right next door to us and we had met one of his assistants, so Tone asked her if we might be able to get Stevie on the hook. He came over to check it out and we played him the record and Tone swears he saw Stevie shed a tear while he was listening to the song. There was no denying it: "Smile" would have been a powerful record even if Pac hadn't been killed. But his death just added so much more weight to the song. It was heavy, heavy stuff. Tragically, it was also all too real.

THE GOOD, THE BAD & THE UGLY

I never knew how well my albums were doing. It didn't matter if they sold five hundred copies or if they sold five million, I never knew. I never even knew if anyone at the label thought they were any good. We just never got any real feedback and we were always kept in the dark—about everything. Every time I turned something in, no matter how good it was or how hard I'd worked, the reaction was always, *Eh, it's all right.*

Nothing was ever good enough. No matter how many records I sold, or how much my name started to ring out as one of the best to ever do it, I was never able to meet J's expectations for me. There was never any praise or any kind of bonus for outstanding performance, or none of that shit. I couldn't even get a simple *Good job.* Instead all I ever got was, *You ain't working hard enough.* Even to this day. I've never gotten a single phone call complimenting me on my records or my

performance. Nothing. I'm not saying I need a trophy or anything, but I was putting in work!

The only way I knew if something was good or not was if Big Mello was fucking with it. Big Mello—Curtis—was a seriously funny dude. I'd met him back when we used to catch the 33 Post Oak together on the Southside. I was in middle school then, but he was a little older and he used to work at this little juice spot, making juices and shakes and shit. He was big into music, too, and we'd ride the bus rapping and beatboxing to each other. Once I got on, I brought him over to Rap-A-Lot, and over the years we stayed tight. Mello was a Scarface fan. If he told me my shit was jamming, then I knew I had something. And that went for all of the niggas around my way. The minute I got word that the Southside was fucking with some shit I'd done, I knew I was good. And it had always been that way with me. From day one, I always wanted to have the most jamming shit in the hood. I couldn't get shit for praise from the record company, but if the niggas in the neighborhood cosigned me, at least I had that.

Well, the niggas around the way were definitely fucking with *The Untouchable* when it came out. It seemed like everybody was. We sent "Smile" to radio in early '97, just a few months after Pac's death, and the song was so striking and everyone was still so sad to see Pac go that it quickly became a hit. It didn't crack the top ten (it topped out at number twelve), but it went gold and is still the biggest single I ever released. When *The Untouchable* arrived in March, the people were ready. With "Smile" working at radio and my reputation for quality music secure in the streets, *The Untouchable* debuted at the top of the Billboard 200, pushing U2's *Pop* down to number two. I was twenty-six years old and I had the number-one album in the country. I was always much more concerned about the money than the charts, but still, I was all over the radio and my album was everywhere. It was

the one time that I didn't need anyone at the label to call and tell me that shit worked. The success of *The Untouchable* was undeniable.

Almost as soon as *The Untouchable* dropped, we started plotting my next album. It was the first time we'd planned a release ahead of time, and even though I usually didn't work like that, this was one plan I could get behind. From day one, the plan was to get me paid.

Rap-A-Lot had just negotiated a new deal with Virgin, shifting distribution from Virgin subsidiary Noo Trybe Records to Virgin proper, and the talk around the label was that the new deal meant more exposure and more bread. The biggest check I'd ever seen from Rap-A-Lot was a $400,000 royalty check after *The Diary* went platinum, and I'd had to pay that shit back (for management or publishing or some shit that the label controlled, I'm not even sure what), so you know I was ready to cash in.

From the beginning, I wanted to do exactly what Dr. Dre had done with *The Chronic*—produce a bunch of incredible beats, pair them with a bunch of dope-ass MCs, maybe add a verse here or there, and really showcase what I can do behind the boards. It was the ideal situation for me. I was already making a ton of beats, and the MCs weren't a problem. The label was stacked, and with a lot of talent—like A-G-2-A-Ke and the whole Facemob—that I'd brought through the door. And I knew guys like Ice Cube and Too $hort would be down when they got the call. Well, shit, I was jamming so hard and the records were coming together so quickly that we decided to make that motherfucker a double album. Pac and Biggie had both won with double albums and we figured, shit, I could carry one, too. The album took less than a year to put together and everyone was excited about it, me most of all. I called it *My Homies*.

Unfortunately, when it came time to release the album, shit didn't go quite as planned. Not even close.

First off, I wasn't feeling the single. Now, the way shit would go at Rap-A-Lot, when you turned the records in, your workday was done and you could never be 100 percent sure that the album that you turned in would be the album that would appear in stores. Sometimes you'd turn shit in one way and then go to buy the album and there'd be shit on there that you'd never heard—a new singer on one record, or a new verse by someone else on another, you name it. There was always some shit going on or being added in at the last minute. You'd hear that shit and it'd be like somebody went in your sock drawer and put their feet in your socks or their ass in your underwear or some shit. It was disgusting. But the label was in control. And if you got pissed off and tried to address it, you might not be able to get a check or J would stop answering the phone, and next thing you know, five or ten years would go by and you'd be like, *Damn, I never got paid for that shit at all.*

And that's pretty much what happened with the lead single from *My Homies*, "Homies and Thuggs." First and foremost, it was J's idea to get Master P and me together on a record. Now, nothing personal against P, but I didn't want him on the album. I didn't give a fuck that P was on fire. It just felt like jumping on what was hot to sell a record, and I've never been into that whole *let me find out who's hot and get them on my album or jump on one their songs* approach. I'm not breaking my neck to get in the studio with someone just so I can ride his wave. That shit has always been corny to me. So when P came through, it was all love because P's my dawg. But it wasn't a big deal to me that we get a song done together. Sure, he was hot and he had sold all of these millions of records, but I'm Face! He was doing him and I was doing me, and I didn't feel like I needed his help to sell my project. Shit, I'd made it this far. I'd be good on my own.

Then J wanted to put that Pac verse on there, too, and that shit was just a complete failure to me. It wasn't like we had some crispy,

never-before-heard verse from Pac that was cut in the booth and mixed and mastered and all of that shit. Nah. We had some video footage of Pac freestyling that my cousin had shot while we were all hanging out, bullshitting and drinking in the studio during the "Smile" session. We had to hunt my cousin down to get that footage, it was that bad. And I was just watching all of this happen, like, fuck, man, this is some bottom-of-the-barrel shit if I've ever seen it. Taking a dead man's vocals off of a videotape to use it in a song? That's the lowest of the low. I know Pac probably flipped over in his grave when he heard that shit.

I thought the record was a fuck-up from jump. If it had been up to me, I would have left "Homies and Thuggs" off the album, but it wasn't my call. And I could say, *I don't want to do this*, or *Don't put that song on my album* all I wanted, but when it came down to it, J was going to do what J was going to do and there wasn't shit to do but accept it. But that was J just being way ahead of me again. He knew that P was that hot and that the fans didn't care about the quality of the Pac verse, they just wanted more Pac. The song wasn't a runaway hit, but it did pretty well at radio and let everyone know that there was a new Scarface album on the shelf.

Still, I thought that whole shit was disastrous. I wasn't trying to sell my shit like that—not with Master P and a piss-poor recording of a Pac verse. I wasn't looking for that kind of help, and I definitely didn't think that song was a highlight of the album. If I had been picking singles, I would have gone with the UGK and 3-2 record, "2 Real," or "The Geto," with me, Willie D, and Ice Cube. Those were the standout records to me. Putting out "Homies and Thuggs" felt like tying a forty-five-pound weight to my reputation and throwing it in the river just to see if it would sink. Those kinds of moves can destroy a career.

Luckily, I was able to float on past it. *My Homies* came out in March

1998, and hit number four on the *Billboard* chart. It was platinum within a month of release. The way I was looking at it, I'm thinking eight dollars a record for a million records sold was going to be mine. My big payday was finally here, right? Eight times one million is easy math. Wrong. The crop didn't come in that year, boss. The crop never came in. I didn't see shit approaching $8 million off of that album. In fact, if I'm not mistaken, when it was all said and done, I think I got one $120,000 check. And that check went right back to management before the ink ever had a chance to dry.

That's what finally pushed me to the point of feeling like, *Fuck this.* For years I'd gone back to back to back, busting my ass to make quality music and put out quality albums, but after a decade with the label, I'd sold over four million albums on my own, plus another two-plus million with the Geto Boys, and I still didn't really have shit to show for it. No matter how many gold or platinum albums I put out, the label wasn't breaking any bread with me. And this was from day one.

OUR FIRST GETO BOYS CONTRACT WAS SOMETHING LIKE EIGHT points split between four or five motherfuckers. And when you signed the recording contract, you were also forced to sign to the label's management and the label's publishing company. Looking back now, it seems so obvious that it was a bad situation for us, but we were kids. We didn't know shit. The whole time, I'm thinking, *It's cool. J's my homeboy, and my brother's not going to let anything happen to me. He'll make sure we're all all right and we're all helping each other get ahead.*

But that's on us. J would always say, *You need to make sure you get a lawyer to look over this before you sign,* but the way I was looking at it, it was like, *Get a lawyer to look over what?* See, J had lawyers and we had him. Every lawyer we knew wanted $600 an hour to consult on a contract. Why do I need to stretch myself thin and spend a few thou-

sand dollars to get a lawyer to check out a few pieces of paper that are coming from a friend?

And then you've got to remember, I was sixteen when I signed, and I was just so happy to get on. Fifty thousand dollars is a lot of money when you're that young, much less a couple of hundred thousand, especially when it means that you can get out of the streets and stop risking your life or your freedom just to make a buck. But as time goes on, you look around and start to realize that the label's really growing and that there's some real money to be had in the music business. And then you start thinking about who's bringing in a lot of that money and who's making all of the records that everybody's talking about and who's really helping to build the label into a powerhouse and a destination, but you can't get any straight answers about the bread and it just starts to be like, *Well, what the fuck is really going on here?*

I remember hanging out with Kool G Rap back in the early nineties, around the time we cut "Two to the Head" with Bushwick Bill and Ice Cube for his *Live and Let Die* album. (This was the song Biggie later sampled me saying *So die, motherfucker, die* for "Ready to Die.") And G Rap was telling me he was about to get $250,000 for some thing or another, and I was like, *Goddamn, that's a lot of money!* No offense to G Rap. He's a fucking legend and he deserves every dollar that ever came his way, but the Geto Boys had hits! "Mind Playing Tricks on Me" was a Top 40 record with crossover radio spins. It was a certified gold single with over five hundred thousand copies sold, and I didn't know anything about a $250,000 payday. After *We Can't Be Stopped* and *Mr. Scarface Is Back* came out, I got a check for about $137,000. Looking back and knowing what I know now, I know I was getting fucked.

It's the oldest story in the book. It was always something. Like, I'd get a statement with no check attached and then when I'd ask what

happened to the royalties on that project or why I wasn't getting paid, they'd tell me it was because I was un-recouped or some shit. Or let's say there was a $700,000 advance from Priority or Virgin for a project and we spent $350,000 to make the album, it would turn out that the $350,000 we spent was my half and the other half went to the label.

It was like we were slaves coming to the master after picking the cotton looking for some sort of compensation for all of the hard work only to be told, *Well, looks like the crop didn't come in this year like it was supposed to. Maybe next year.* And this was every six months. I'd get an advance or enough money to eat so I could keep working or maybe get a new car, almost like a handout, like, *Here, take this.* I never knew what exactly I was getting paid for at any given time. More often than not, at some point I'd be told that I actually owed the label money. I was almost always un-recouped.

Whenever I'd ask about seeing some paperwork to clarify everything, the response was always the same: *We're getting it together.* Or *We'll have it for you soon.* And so we'd go back out on the road, come back to Houston, ask about seeing the documents, and they'd hit me with *Oh, we had to put someone else on it because the other guy fucked it up,* or *Oh, right, we're getting it together now.* Always something. Always not delivering. And when I would finally see the statements, there were so many deductions there was no way I'd have anything coming to me, and I'd probably owe the label again. I think even if the contracts could be read a different way, there were just so many loopholes that it felt like there was no way I could ever get a fair deal. And this went on for years.

But James just kept selling me a dream. He was an incredible salesman. It was always *Next time.* Next time I stopped by, or next time I had a hit. Next time it would all get worked out and we would all get paid. Just: *Next time.* Of course, then next time would turn into five years, which would turn into ten years, which would start to turn into

twenty years, and finally, it'd just be like, *Goddamn, bro, when are you going to start sending me some fucking money?* And I'd just be back in the same cycle. *Well, we just set up a new accountant.* Or *We're looking at it, but we've got a new system.* And the next thing I know, years have passed and I haven't seen anything explaining what money was coming in, where it was coming from, where it was going, why it wasn't going to me, nothing. All of that time, and I haven't seen shit.

And the worst of it was, in order to get an advance on the money I'd already made for records I'd already sold, it seemed like they would always ask me to sign a contract extension. It didn't matter what I needed the money for. Even if it was to bury a family member, the response would always be, *Cool, but before we can cut you a check, just sign up for a few more albums and a few more years on the label.* Again, this is for records I'd already made and sold! It just felt like they always had me over a barrel, and I was fucked.

I just never thought James would do me like that. We'd both started together, trying to make something off of music, make an impact, be heard, and get rich. I saw every gold and platinum album, every song used in a soundtrack or in a commercial, every show, every guest verse, every new signing, as our victories and our wins. Together we were beating a corrupt-ass, fucked-up system by rewriting the rules and creating a whole new playing field for a brand-new game. But they weren't our victories. They were his.

And to anyone coming up in the game, please take this advice: you get in the homeboy business and you think you're going to make it with your friend, but the sad truth is, nine times out of ten in that situation, your homeboy isn't going to play fair, because he isn't really your friend. It's on you to handle your business. Act accordingly.

As for me, after *My Homies* didn't deliver my big payday as planned, I stopped recording. I was mad done.

THE LAST OF
A DYING BREED

The next two years were all sorts of fucked up. I helped Devin out doing some production and mixing on his solo debut, *The Dude*, but after that came out in June of 1998, shit got pretty dark.

On November 17, 1998, we dropped the sixth Geto Boys album, *Da Good, Da Bad & Da Ugly*. It was a Geto Boys album in name only, and if you ask me, it was an epic fail. I haven't listened to it in a really long time, so it might be better than I remember it to be, but I wouldn't count on it. Bill had left the group and I wasn't down to make that album at all. It felt like *Till Death Do Us Part* all over again, except worse. It's more of a Rap-A-Lot compilation than a Geto Boys album. I wasn't tripping too much because I was already off doing my own thing trying to make something pop for myself, but every song is featuring some other artist that was never in the original group, and the whole thing felt thrown together just to get something in stores and capitalize on the Geto Boys name.

This was around the time that Master P was making a killing with No Limit, throwing out records damn near every fifteen minutes it felt like. You had to respect it, but I think the success of his business model started to fuck up the game. After everyone saw what P was doing, focusing more on quantity than quality and still selling like a motherfucker, it made a lot of other labels think that's the way they should go about it, too.

Next thing you know, it started to feel like James was trying to take Rap-A-Lot and turn it into the No Limit Tank. The album art switched to that Pen & Pixel look that No Limit had made famous and we were signing everyone, carrying a roster of fifty-five acts or some shit and putting out new albums almost every week. But when you're releasing albums at that clip, they can't all be great, right?

Now, I could be wrong about all of this. Maybe J really saw something in signing all of those acts and pursuing that strategy, something that went beyond just trying to bolster the company's bottom line. But it just felt like way too much shit to me. Way too much. J had always done his own thing, and I just didn't think he had to do what everyone else was doing in order to continue to be successful. He'd made it this far doing it his own way. Why start doing it someone else's way now? So while it might have been great for J's money in the short term, it just felt like the degradation of a very powerful machine that we had all helped build. And as time went on, I really felt like it started to compromise the integrity of what we'd built and our reputation for putting out quality music. If you ask me, the brand suffered as a result.

But that was my opinion, and I had tons of those. At the end of the day, I didn't have too much input. And I definitely didn't have final say. James was going to do what James was going to do. It was his label and he was going to run it how he wanted it run. And when it really came

down to it, I was pissed about the paper and I was ready to go my own way, but I was still down with the label and I was still down with J, so whatever he wanted to do, I rolled with it. But in the end, *Da Good, Da Bad & Da Ugly* was a flop. It didn't even go gold.

WITH MY RECORDING CAREER AT A STANDSTILL, I HAD TO TRY to find other ways to get money. But every time I tried to find a publishing deal or some other arrangement for me to make money off of my music, the label would step in, say I was still on contract, and shut it down. I couldn't do shit. So in early 1999, I went to New York to try to find my way out of the Rap-A-Lot mess and into a new deal. I was hanging out with my longtime booking agent, Peter Seitz, and telling him about all of the shit I was going through and after he's done hearing me out, he's like, *You should meet Bert Padell.*

Now, Bert Padell is no joke. He's a big-time money manager who's worked with everyone from Faye Dunaway to Madonna to Eric B. and Rakim. Shit, Biggie even shouted him out on 112's "Only You (Remix)" back in the day. (Remember *Stash more cash than Bert Padell?* That's Bert Padell.) When I start explaining to Bert Padell that I can't prosper in my current situation but that I haven't been able to get clear of all of my obligations to James and Rap-A-Lot, he tells me that I should talk to Londell McMillan, who's this beast of a lawyer who's represented everyone from Prince and Michael Jackson to the NFL and is known for saying shit like *You don't get what you deserve, you get what you negotiate.* Now, that sounded like damn good advice.

So I get Bert Padell and Londell McMillan on my side, and then we go to see Lyor Cohen, who had just become president of the newly created Island Def Jam Music Group. We're sitting in Lyor's office high above Manhattan, just the four of us, talking, when I tell Lyor that I

think he should look into doing a Def Jam South. It wasn't something I'd thought about before or had in mind to bring up, it was just an idea I had in the moment and I figured it was worth a shot.

After years and years of being neglected, dissed, and dismissed, the South was finally—officially—on fire. Master P had taken the footholds established by Rap-A-Lot and Suave House (another Houston-based rap label with an incredible roster, run by a guy I used to throw newspapers with as a kid, Tony Draper) and blown the market wide open. The Tank was the talk of the music industry, and all of the majors were scrambling to catch up. It was just like what had happened on the West Coast after Ruthless and Death Row proved the market's potential in the early nineties. In the late nineties, rap's new gold rush was on and everyone was looking to cash in on what they called the Third Coast.

By 1999, it seemed like anyone with a gold grill and a southern accent could get a deal, but as much as I wanted to get paid, I wasn't interested in scoring quick checks off of some bullshit. I'd always been about quality music, regardless of where it was from, and I knew that even though Def Jam was solidly associated with the East Coast, the label had also always been after the same thing. There had always been plenty of money to make and great music to create in the South. So the way I saw it, if Def Jam wanted to make a play in my backyard, who better to lead the charge than me? All I've ever done is bring dope shit to the table. Facemob, A-G-2-A-Ke, Ganksta N-I-P, DMG, N.O. Joe, Mike Dean, Devin's *The Dude*, the Geto Boys' *Resurrection*, all of my own solo shit—in one way or another, all of it came through me. And I could certainly do the same thing for Def Jam. All Lyor had to do was say the word.

At least, that was my pitch. Not that I expected Lyor to go for it. But he took it to Todd Moscowitz, who was Def Jam's general manager

at the time. Turned out Todd was into the idea, too, so we all started talking about what it could be, and we talked and we talked, and then before you know it, we're setting up an office in Atlanta and I'm the first president of Def Jam South. Honestly, I'm still not completely sure why they went for it. But they damn sure did.

I know a lot of people talk shit about Lyor, but I'll always give him props for that. I was in a fucked-up situation, and Lyor and Def Jam changed that. If they hadn't stepped up with that deal, I don't know if I would have been able to keep doing music and still provide for my family. I might have been run out of the game. But with Def Jam South, Lyor changed my life. I never expected it, but I'll always respect him for it.

I'll always remember what he told me. He said, *I'm going to make you a deal that's going to knock your socks off.* And that's what he did. Lyor Cohen didn't sell me a dream. Lyor Cohen made me a millionaire.

But I wasn't out of the woods just yet.

THE G-CODE

I'll never forget the first time I met Jack Schumacher. It was 1999 and he pulled up to my house, stepped out of his car, and in his country-ass drawl, hollered, *Scarface! I'm a fan!* And then Schumacher and the rest of those motherfuckers from the Drug Enforcement Agency searched my whole damn house.

It was an insane time. But we knew the DEA and the cops were watching us. At least I know I did. The government had been after James and Rap-A-Lot since the very beginning, all the way back to '88 when that car got stopped with the seventy-six ki's. James wasn't anywhere near that shit when it went down, but you know how it goes. You've got some young black men out here making money, and that shit draws attention. That's why James was always so adamant about me putting that shit down. I think he knew the more successful we got, the more heat we would attract, and he wasn't about to get caught up in some drug shit and have that fuck up the whole operation, so

he told us straight up, *You either do this or you do that, but if you do that, you're not going to do that shit over here.* So I walked away with the little money I had left and never looked back. And it was the right choice, too. All the dope in the world can't match up to a legitimate hustle. Nothing would have set us up as well as music did.

But you already know the government wasn't trying to hear that shit. They were always pulling us over and fucking with us. I know J got caught up in some bullshit in the early nineties where they just wouldn't leave him alone and he filed a complaint and told those people to get off of his ass. It kind of calmed down a bit after that, but in the late nineties that shit started up all over again. By 1998, it had gotten to the point where damn near anytime somebody got shot or killed or robbed or pulled over or even got a jaywalking ticket any-where in the whole city, it seemed like the Feds would show up at the label's office asking questions trying to pull us into that shit in some kind of way. It was ugly.

Then they started setting niggas up and putting our friends away. Like in January 1999, they locked up the homie Spook after putting drugs and money in front of him their damn selves. It was their shit! And they popped *him* for touching it. He got busted for some shit that wasn't even really there. That's just how they were getting it in: by any means necessary, they were determined to shut down our whole shit. They were raw with it. All the way raw.

And I knew they had taps on my phones. Or maybe I wasn't totally, 100 percent sure, but I got pretty fucking suspicious when not too long after I started calling around trying to find a roofer to come over and do some repairs, this dude who I'd known for years, Ronnie Carboni, starts coming by asking if I need any work done on my home. Now, I'd known Ronnie for maybe twelve years or some shit and he'd just gotten out of the federal penitentiary. He'd been a roofer before he

went in, and he's rolling through the neighborhood one day when he sees my uncle outside. They start talking and my uncle tells him that I'm looking for someone to put a metal lining up under the tiles on my roof, and Ronnie says he could do it and quotes him a price much cheaper than all of the other quotes I'd been getting.

Well, shit, I'm usually down to help a guy out, especially if it's going to save me some money, so I give Ronnie the job, but almost right away, he starts acting funny-style, and I'm no dumb motherfucker. He's coming over, fixing leaks and trying to sell me a whole new roof and shit, but at the same time he just keeps asking about drugs— where he can get it, if I'm interested, if I know anyone who might want to buy some shit off of him, the whole shit. Then one day he just comes right out with it.

Face, you think J can help me get my hands on ten ki's? he says.

I'm like, *Nigga, what?*

So this rotten rat motherfucker goes, *Do you think J would trade me ten ki's for five hundred pounds of weed?*

Now, I'm on that no-old-friends, no-new-business shit, so you're going to have to try real hard to get me caught up in that dope shit. I also put that drug shit down so long ago, I couldn't really tell you anything about it today. I might be able to point you to somebody who could tell you where you might want to look or who you might want to call, but otherwise, I'm so far out of the game I'm not going to be much use.

So I tell Ronnie as much, but he just won't let it go. He's always trying to take the conversation back to some drug shit. He keeps asking and asking if I might be able to do this or that for him, and I just keep telling him, *No, bro, I don't know anybody who can help you with that,* and *I don't know anything about that, homie. I've never been a part of no shit like that.* And, *Don't nobody do shit like that anymore. We make our*

money rapping now. I was always trying to steer the conversation back to whatever it was we were supposed to be talking about—the roof or the house or the next project, whatever it was—but at some point I tell him while I don't know shit about any dope, I definitely know something about some good-ass weed, because I always had something nice to smoke on laying around.

Of course, I thought Ronnie was bugging, but I didn't know he was mic'ed up the whole time and recording our conversations. But that's exactly what was going on, and that motherfucker was persistent with it. Well, somewhere along the line he ends up meeting a good friend of mine, George Simmons. The fucked-up thing is that George didn't know shit about drugs. He washed cars. I guess George saw an opportunity to make some extra money off that shit Ronnie was talking about, but since Ronnie was working with the Feds, George, and a couple of other guys I knew ended up getting nailed. And it was a damn fucking shame. It really was, because Ronnie and the Feds weren't after George, they were after me, and it was because they were after James. And the whole time, Ronnie had just kept on me, trying to get me to cut him a personal check, but I wasn't with that shit. He'd ask for a check made out to him and I'd always insist on making it out to his company. And I'm glad I did, too, because the way it all went down, I know for damn sure that if I had cut him that personal check, he would have tried to make it seem like it had been for something else and not just to get my roof straight.

Well, there was just so much crazy shit going on and Ronnie was acting so funny-style, even before George got caught stepping out of his normal sphere, that I told one my partners about it and he gave me a little device to plug into my home phone to see if that motherfucker was being tapped. And do you know that the day before Schumacher showed up at my house, I plugged that thing in, and

as soon as I hit that switch that told you if your shit was tapped that motherfucker lit all the way up. They were on my line listening to everything I was saying. I wasn't saying shit because I wasn't doing shit, but you bet your ass the very next day, they were at my door with a search warrant and Jack Schumacher is in my driveway calling my name and telling me that he's a fan. Can you believe that shit? It was that crazy.

So they went all through my house looking for anything they could find to try to get me caught up, but there wasn't shit in that motherfucker except for some weed I had for a personal stash. They took me in over that but they weren't able to put shit on me except for a misdemeanor possession charge. I paid the fine and they suspended my license for six months over it and that was that. I was free to go.

(Incidentally, this whole shit with Ronnie is what got Lil Troy out here years later calling me a snitch. But the truth is, I didn't snitch on shit. I didn't snitch on someone to get a reduced sentence or give someone up under interrogation, none of that. They had me on a misdemeanor possession charge. I didn't have to give up shit to get out of that. And there wasn't a damn thing they could do about it either. I was fucked up over what this rotten rat motherfucker Ronnie Carboni did to George, but I was set up without my knowledge and George got caught up in a sting as a result. It was a damn shame, but it doesn't make me a rat.)

Of course, those motherfuckers weren't about to let that shit go that easily. I'm telling you, the DEA was raw. They were out here telling people, *we're on to some rich niggas.* The only way we were able to get the DEA and the Houston police department to back the fuck off and let us go about our business was to appeal directly to Congress. Thankfully, Representative Maxine Waters, who had been head of the Congressional Black Caucus, was able to step in on our behalf and get

Attorney General Janet Reno and the Justice Department to look into that shit. Ultimately, Schumacher got reassigned to another desk and the DEA's Rap-A-Lot investigation was closed. And that was all James. Like I keep saying, he was light-years ahead of all of us. He went in at the highest levels.

AFTER ALL OF THE SHIT, I WAS REALLY IN NEED OF A CHANGE OF scenery. With all of the Rap-A-Lot bullshit plus the shit with the Feds, I was just completely over Houston. I'd had enough with the whole scene and I needed to get out.

The Def Jam deal wasn't finalized, but it was close, and as we worked through the finer points, talk shifted to where Def Jam South should be located. I pushed for Atlanta. In the South, it was the spot for everything. There were a lot of great studios there and a ton of excellent musicians. Atlanta was live, and I knew it would be a great city to set up shop in and do great work.

Of course, as soon as it started to look like I was really about to make that Def Jam move, Rap-A-Lot comes back and says I owe them one more album under my current contract. By that point I was so ready to be done with that whole situation, it was just like, *Whatever. Let me get them this fucking album and just get the fuck up out of here.* And that's how *The Last of a Dying Breed* came about. I didn't want to do that album, but it was the only way I was going to get free of my obligation to the label, so I just went to work. But that shit was so fucked. The whole time I was working on it, I couldn't wait to turn that album in and get the fuck out of Dodge.

I've written a lot of tough, difficult songs during my career, but the most personal song I ever wrote is probably on that album. I was just going through so much in my life at that time, and I put it all in the song "Sorry for What?" It's all there—the suicidal thoughts, the drug

use, my deepest doubts and regrets, shit, even a Pink Floyd reference (*Is there anybody out there?* comes from *The Wall*). If you really listen to that record, you can hear me trying to find my way.

I remember when I wrote that song I was just so confused about everything. My life really did feel like a maze. I was twenty-nine years old, and I was trying to find myself and my purpose in life. I was looking for the right words to make the right song, and searching for how to be the right husband and the right father with the right relationships with his family and his children. It was a really, really difficult time, and I felt like I was trapped, lost in a world of false starts and dead ends almost like I was going in a fucking circle of pain and disappointment so impossible to escape that it had gotten to the point where I'd lost everything, including my wife.

And I was just hurt. I was really, really hurt. Because as great as the music was that we made and as great as the sense of brotherhood and friendship could be in the group and with the label in the bright times, there were just so many incredibly dark times clouded with so much frustration and pain. And drugs. If you weren't drunk, you were high on whatever it was that we were fucking with that week. And if you weren't high, you were drunk. It was just a way of life. But it's one thing to be young and partying and it's a whole other thing to be in a place where you feel like shit is really fucked up and you're turning to drugs just to try to get through it. But shit was really fucked up, and we didn't know any other way.

I've always been surprised that people liked that album so much. It debuted in the top ten and the critics gave me a lot of love. *The Source* even named me Lyricist of the Year at the 2001 Source Awards after it came out. But I just never fucked with it, not when I was making it and not after it came out. I guess I'm glad that the fans like it—you always want people to appreciate your art, no matter how fucked up the

situation was when you were creating it—but even after all of these years, I still have a hard time seeing *The Last of a Dying Breed* as any kind of career highlight. From the moment I decided to take it on, it was always an obstacle. It wasn't something to celebrate. It was something to overcome.

Still, I couldn't walk out the door without a parting shot at those crooked-ass cops. I wanted to let them know that we'd beat them at their own crooked-ass game, and on "Look Me in My Eyes," I broke down the whole thing. I even called out Schumacher by name. The media went nuts with that shit, and I know it fucked with them. Or as I put it on the song, *I know you crackers pissed, I can see it your eyes.* Say what you want about me, but even with one foot out the door, I always spit the truth.

BACK FOR THE FIRST TIME

CHAPTER 27

SOUTHERN HOSPITALITY

As soon as we got the Def Jam deal finalized, I moved to Atlanta. I really needed a change of scenery, and I can't even explain how much it meant to me. I was so happy to have a job and to be able to take care of my family and handle my business. After twelve years on the slave ship, I was finally free. I felt like I'd finally gotten unstuck. And Universal broke bread like a motherfucker. For the first time, I felt like all of the other bullshit I'd gone through had been worth it.

See, I didn't realize there were millions of dollars in the music business for me until I took the job at Def Jam. Like I said, despite all of the records I sold during my career, all of the records I produced, and all of the talent that I brought to the label, I think the biggest check I ever saw at Rap-A-Lot was for about $400,000. I'd be surprised if I made more than $4 million over the course of my entire Rap-A-Lot career. If someone could show me some real documentation proving that I made more than that, I'd be shocked. But I was making more money

a year at Def Jam as an executive than I ever made at Rap-A-Lot as an artist. It's not like this is some big secret. If you ask anyone who's spent time at both labels, I'm sure they'll tell you the same thing. See, Def Jam is a big business. And as much as you might hate the major labels and all of the politics and bullshit that you have to go through sometimes to get attention or to put a record out, at the end of the day, they have to settle their books. They have to do it open and fairly, and it's all transparent. You know where the money is, where it came from, and where it's going. And I know there was a hell of a lot more money in that system for me.

I didn't see a million dollars in one check made out to me until I signed with Def Jam. My salary was about $350,000, plus I was getting paid for my work as an A&R, so I was taking home about seven figures a year (and that's without putting out any of my own music). That's when I finally became a millionaire. And, shit, once I saw my name on that check, I knew I'd never gotten a fair deal. And I never looked at the business the same way again. When I became president of Def Jam South, that's when I finally, truly, cashed in.

JUST LIKE L.A., ATLANTA EMBRACED ME WITH OPEN ARMS. I lived in Dunwoody and then moved over by Ebenezer Baptist, which had been Dr. Martin Luther King Jr.'s church. I had a great place and it was a great time to be in the A. For Def Jam South, my primary responsibility was to find new talent to bring into the fold, and I spent my time working my ass off to do just that. PatchWerk Studios became my home away from home. It was still just a few years old when I got there and it was super nice. They have a great setup and as their reputation solidified, everyone was coming through there—Michael Jackson, Whitney Houston, you name it. You really wanted to be a part of that. So I would post up in there, meet new artists, and work with them to try to make shit pop.

I've always believed in the voice. I can't stand it when people want to talk to me about an MC that sounds like someone else. Motherfuckers are always coming with that shit, like, *I've got a rapper, man, dude sounds just like B.I.G.* Or, *Man, you've gotta hear the guy I'm working with, he sounds just like Lil Wayne.* I hate that shit. I don't want to work with anybody who sounds like someone else. We've already got a Lil Wayne. We've already had a B.I.G. and a Pac. Hip-hop's got a Drake already, we're good. So for me, before the rhymes, the songs, or the wordplay, it always starts with the voice. I'm a sucker for a dope-ass voice. Because as soon as I hear that, I can immediately home in on what the artist's sound is going to be—how the production is going to feel, what beats he should rap over, the way the songs are going to hit. Like, if you look at everyone that I brought in over the years, from Smit-D to DMG to pushing for Devin to get his solo look—they all have their own unique-ass voice, and that shapes the records they make. It all starts with the voice and everything else falls into place. So when I got to Def Jam, I didn't switch my shit up, I just doubled down and went even harder, combing the South for the MCs with the dopest voices and the most unique sounds because I knew that was how we were going to make the most impact on the game.

The first guy I tried to sign was Pastor Troy. This was right when he was first making noise. He had the "No Mo Play in G.A." record out there slamming Master P, and that shit was super tough. It was tearing through the streets of Atlanta. You heard it everywhere you went. And Troy had an incredible voice—just that thick, deep, militant Atlanta growl, almost like a bark. And he was fearless. Going after Master P right when P was running things in the South was either genius or nuts or both. Either way, that shit was hard.

But Pastor Troy was a little too early for Def Jam. We were just getting set up and I don't think they really understood southern music at that point because when it came time to cut the check to bring

him on board, they weren't quite ready to make that move. See, the thing about Troy was that if you didn't have an ear for it, it was easy to dismiss him as just some dude out here yelling and hollering and making a lot of noise over nothing. But for motherfuckers down South, that shit stood for something. It was almost like some punk-rock shit, bucking against the system—any system—whether No Limit or otherwise. And we've got plenty to buck against in the South, and Troy tapped directly into that. He had it, and I got it immediately. I just couldn't get Def Jam to get fully on board fast enough to make the deal. In the end, Troy put out *We Ready, I Declare War* independently, sold a gang of those, and signed to Universal proper.

After Troy didn't work out, I started looking at T.I. It was clear from day one that Tip could rap his ass off, and I wanted to bring him to Def Jam hella bad. He was a young, fly lil nigga back then and he had that pimp gangsta shit down cold. He was already on Polygram when I met him, and even though they weren't doing shit with him, I couldn't get him down with us. That one hurt because he fit right in with what I was trying to do with Def Jam South—hook up with super-dope southern MCs with the potential to be career artists that could live up to the Def Jam name. It didn't work out with Tip, but I was right there. I'm telling you, I've got that ear. I know when I hear some dope shit that's really going to work.

After shit didn't pan out with Tip, I went after David Banner. I always fucked with David Banner. He'd been making some noise with his group, Crooked Lettaz, and his independent album, *Them Firewater Boyz, Vol. 1*, was serious business. Banner was the truth. He could produce and he could rap and I knew we could do something with that. But I couldn't get everyone in the boat for him. That was the big thing at Def Jam. You'd bring someone in, talk them up, play the records, and then the question would always be, *Well, is everyone in the boat?* We couldn't move until everyone was in the boat.

I'm not going to lie, that shit could get frustrating as fuck. But you couldn't get too mad at it because the label's track record was so damn solid. We also had one hell of a team. Just think about it. Not only did we have a legend in Lyor as well as Todd (who later joined Chris Lighty—RIP—as a partner at Violator Management and then went on to become president of Warner Bros. Records), we also had Craig Kallman and Julie Greenwald, who both went on to head up Atlantic Records together. At radio, we had Mike Kyser, who later joined Craig and Julie at Atlantic as the label's first-ever head of Black Music. Kevin Liles was the president of Def Jam at the time, and then we also had Tina Davis, who picked up Chris Brown when she left and went on to make a killing.

And that was just in the big building in New York. In our Atlanta office, we had Erica Garey, G. Wallace, and Peppa Williams, who went on to break Yo Gotti. It was a hell of a team. And it made my day-to-day job easy as fuck because they were so on point. I'd go to the office, meet with everyone and strategize, talk about dope shit we wanted to go after, and then go out and work to make that happen. Then it was just a matter of getting everyone in the boat.

Still, the rule of thumb is that a wise man seeks many counsels. So if Kevin Liles was in the boat, but Kyser didn't think we could do anything with the artist at radio, then we didn't do the deal. Or if Kyser was in the boat and Julie wasn't, then we didn't move. And that's just how it would go. We'd sit down, play the records, and talk as a collective about what we thought we could do with the artist or the project, or whether we thought we could do anything at all. And then we'd make the call.

After Tip, I brought in Rick Ross. He was recording as Teflon at the time over at Suave House, but he hadn't really had much luck getting on. I thought he had something, but Def Jam didn't want to fuck with him like that at the time. Of course, they eventually came around and Rick Ross went on to become one of the building's biggest stars. I re-

ally wanted to work with him, but I guess the timing wasn't right. We were too far ahead of the curve.

Then we tried to get Stat Quo. Stat says one of our talks is what really pushed him to try to take rap seriously and turn his music into a career. I know why I did, too. He's the shit. He's so dope that Eminem and Dr. Dre both signed him—to Shady and Aftermath, which blocked us out of the game. And the same thing happened with Slim Thug, Paul Wall, Chamillionaire, and Lil' Flip. At one point or another, I brought them all to the table. I know what I saw and what I heard in all of those artists, but in every case, we just couldn't get the deals done and they ended up somewhere else.

So did we miss a few things? Of course. Do I wish all of those artists could have come out under Def Jam South and we could have worked with all of them to make them all stars? You're goddamn right. But I was happy to watch all of those guys win, even if it wasn't with us. It just further validated my taste. I'm not mad at the way things worked out. I loved my time at Def Jam South. And I loved my team. It was a bullshit-free job, and when we all synced up and it clicked, it clicked. And that shit worked like a motherfucker.

I WAS HOT TO BRING SOMETHING TO THE TABLE AS SOON AS we walked in the door, but we just couldn't make it work. I knew we'd been looking at dope shit so I knew I'd been doing my job, but that only goes so far. We needed to get a big deal done. This was 1999, and the Atlanta hip-hop scene was really taking off. OutKast and Goodie Mob were breaking nationally, and I felt like if we could get Def Jam behind an Atlanta artist, we had a real shot at making something pop.

I'd known Ludacris for years. I used to see him all the time in the late nineties, going in and out of spots in Atlanta. He went by Chris Lova Lova and he was an on-air personality at WHAT at the time.

I didn't know he was trying to rap and when I started to hear that some of his records were taking off, I didn't think too much of it. I just figured he was playing his own shit on air, and that's why it was blowing up. Then I found out that the station that was pushing his records wasn't even the one he worked at, and I was like, *Goddamn!* And I hit that fool up, like, *What's up? Why you ain't tell me you have a hit like that?*

He told me he'd gotten sick of trying to talk his records up and decided to put his shit out on his own and let the music do the talking. Well, shit, the music was saying a lot. He dropped *Incognegro* in August of 1999 through his own label, Disturbing Tha Peace, and that motherfucker immediately made some serious noise. See, the thing about Luda wasn't just that he was funny as fuck and he could rap his ass off—from the very beginning, Luda knew how to make a song. He always says it's because of his years on radio, and shit, maybe so. Whatever it was, *Incognegro* was packed with solid fucking records and some great producers, and he'd put it together all on his own, without a major's input or support. He also had an incredible voice. I knew we had to get him down with us.

Well, in late spring of 2000, I'm up in New York shooting the video for the Ruff Ryders' song "WWIII." We're out in Brooklyn or Long Island, or wherever the fuck we are, with Snoop, Swizz Beatz, Jadakiss, and the rest of the Ruff Ryders, and Ludacris's business partner, Chaka Zulu, is there, kicking it on the set. So we're talking between takes, and Chaka starts telling me that Luda is getting close to signing a deal. And I tell him, *Man, please. Please, let me just sit with him first.* I'd had too many deals slip through my fingers. I was determined to not let this one go.

Chaka agreed. He said he'd let me make Luda an offer before he signed anywhere else. So Chaka, Luda, and me all go into Kevin Liles's

office in New York and sit down to talk it out. Well, shit, by the time we walked out of that motherfucker, we'd agreed to the offer and the terms and the deal was done. Everything fell into place. I called the play, took the snap, and then gave the ball to Luda and his team, and with Def Jam out in front, they took it to the house.

That was one of the things that was really great about working with Luda and Chaka and their whole DTP team—they were really hands-off. Luda didn't need a lot of hand-holding. You get these other cats out here that need to be babysat through the whole process, but Luda wasn't like that at all. He knew what he wanted and he knew how to deliver. His shit was unreal. He'd already sold thirty thousand copies of *Incognegro* before we got involved. We just put that muscle behind him and gave him that little extra push, and then, bam! He was out of here.

We did the deal early in the summer of 2000, took a bunch of records off of *Incognegro*, added in the song "Phat Rabbit" that Luda had cut with Timbaland for Timbaland's 1998 album, *Tim's Bio: Life from Da Bassment*, plus a couple of other tracks, and had *Back for the First Time* ready for an October release. We used *Incognegro*'s "What's Your Fantasy" as the lead single, which turned out to be a brilliant move. Motherfuckers loved that song. It was a Top 40 hit and helped drive *Back for the First Time* to a top-five debut on the Billboard 200. And he was a debut artist, too, out here making a killing.

The funny thing is that "What's Your Fantasy" wasn't my favorite song off of that album. But the machine knew. And even though I was the president of Def Jam South, I didn't really have control over the singles. I offered my input, of course, but we had a whole radio department for that, which was fine by me. I've never liked thinking about music in terms of singles and marketing and I wasn't about to start now just because I had a new job, especially if they weren't asking me to. Why would I want to get in the way of the pros?

I wasn't at Def Jam for that. I was there to locate talent and push the shit that I liked. That was my role there and that was my role in the Luda deal. I found the dope shit, I brought it to the table, and I said how much I thought the deal should be worth based on what I thought we would be able to do with it. That was my role on the ship. And truthfully, when we'd all sit down—whether it was me and Julie and Todd, or me and Julie and Kevin or Lyor, or whoever it was on that executive level—I always felt like the freshman in the room. They all just had so much more experience than me on that side of the business. I'd helped find, recruit, and work with talent at Rap-A-Lot for years, but I'd always been an artist first. But Lyor, Todd, Julie, Craig, Kevin, and all of them had been on the ground floor, working with Russell Simmons to build Def Jam into an institution and an empire, so when I was in the room with them and they were talking, I was listening and learning.

Just as "What's Your Fantasy" was topping out at number twenty-one on the Hot 100, we dropped "Southern Hospitality" as Luda's second single and did it all over again. "Southern Hospitality" took off and ran through radio all through the winter of 2000–2001 and into the spring. It was Luda's second Top 40 hit. Incredible. Once the records died down and all of the sales were added up, *Back for the First Time* sat at over three million copies sold. It was the first time I'd ever had a hand in a multiplatinum album. Then we did it all over again with Luda's second album, *Word of Mouf*, the very next year—another top-five album with over three million copies sold. Shit, Luda even got a Grammy nomination for Best Rap Album off of that one. We hadn't just signed an artist. We'd signed—and helped make—a superstar. You're goddamn right.

THE FIX

Originally, I wasn't really thinking about doing another album. I didn't mind having a job. The money was good, my team was strong, and I was doing what I really enjoy doing—hanging out in the studio, working on records, and scouting talent. My family was straight, my bank account was padded, Luda was popping, and I thought it might finally be time for me to put down the mic and step away from this rap shit, at least as far as me making my own records was concerned. Shit, I'd been in the game going on fifteen years, and I'd been talking about retiring for probably about ten of those. It felt like it might really be time for me to finally walk away.

Lyor wasn't hearing it. He wanted me to finish my career at Def Jam, and by that, he meant he wanted more music. If I couldn't agree to multiple albums, he at least wanted me to make one. He was sold on the idea. He wouldn't take no for an answer, and once again he broke out his checkbook to prove just how serious he was. He offered

me a hell of a deal, and it was something I had to look at. Here was a chance to collect a big-ass check from a company that I knew was legit (and wouldn't come through talking all that bullshit when it was time to collect), and to record for a label that I'd known and admired my whole life. Now that was an offer I couldn't refuse.

We were at the Def Jam office in New York when I signed the deal. Lyor broke bread like a motherfucker and the money was in my account before I even got downstairs. I remember I was staying at the Time Hotel in midtown Manhattan, and Def Jam had a little congratulatory hangout to celebrate. L.L. Cool J stopped by, and at the end of the night, I gave the bartender a couple hundred bucks to play nothing but Van Morrison, drank a whole bottle of Tuaca and got fucked up! Usually, if you were getting money like that anywhere else, there were going to be all kinds of strings attached, but at Def Jam, there were no ifs, ands or buts. There wasn't any extra shit that came with that check. It was my actual money and I could do whatever I wanted to with it. Life was good. And what a great thing, too, because that album—*The Fix*—turned out to be one of the best albums I ever made.

There were so many things working in my favor on that album. For one, I was rich. I'm talking, maybe for the first time in my life I went into the studio without worrying about money—not how much I was getting, not if I was ever going to see what was discussed, not if I would get more money if the album was a success or not, none of that. I was already straight before I even went in the booth, and I can't tell you how much financial security helped me just relax and focus on making the best music I could possibly make. And it wasn't just my own personal finances that were in good shape: the whole project was well financed. I had the best beats, the best studios, and the best engineers all at my disposal. I was more supported than I'd ever been, and you can hear it in the music.

It's no accident that the album is considered a classic. When you support artists and give them a great environment to create in, it doesn't matter whether they paint, dance, draw, write, rap, act, or what, they will make the best art they can make every single time. And for *The Fix*, I finally had that luxury. For the first time, I was working on an album for a label that believed in me 100 percent and didn't want anything from me except for me to make the dopest album I could possibly make. And they went out of their way to make that possible. They were down to spend thirty or fifty grand on one track, which was unheard of at Rap-A-Lot. So if I wanted to work with the Neptunes, there wasn't a whole lot of discussion. They wrote the check and next thing you know, the Neptunes are producing a song on the album. We had a real budget for that album, and that opened up avenues to making the best music possible that would have been closed otherwise.

We weren't able to get everything we went after. I was hoping to get Stevie Nicks on "In Between Us," but by the time we got her to agree to do it, the album was already done. Instead, that's Mike Dean's wife, Tanya Herron, on that song, working off of a reference track I put down with Stevie Nicks in mind. (That's actually me singing on the intro/title track, though. No Auto-Tune or anything. Bet you didn't know I had it like that!) But we got most of what we wanted on there, and Def Jam did that. They made it happen. With that kind of support from the label, I felt like I had to do everything I could to repay them. I locked in.

Then there was Kanye West. Kanye played a big part in *The Fix*, and he's semi-responsible for the success of that album—him and Tina Davis. And Kanye was still just so young. We started working on *The Fix* in 2001, not too long after he got done working with Jay Z on *The Blueprint*, and he was just super enthusiastic about making beats. Nobody else was really looking at him as this incredible producer yet—

this was still well before *Get Well Soon* and *College Dropout* and all of that—but if you'd had the opportunity to spend any time working with him, you could tell right away just how special he was. He was super dope from day one and it was so clear that as soon as he started getting more work, he was out of here. Fortunately, we were able to hook up when he didn't have quite as much shit going on and all he wanted to do was jam. A couple of years later, he blew up and you know how it goes—all of a sudden you'd try to hit him up, like, *Kanye, where you at, dude?* And you know—no phones.

I remember the first time I heard about Kanye, it was while I was working on *The Untouchable* album. James brought me a CD of his beats and was like, *There's this dude out of Chicago who says he wants to work with you because he just really, really loves your shit.* James popped the CD in and it had the "This Can't Be Life" beat on it before that was even a record, and I thought that shit was so cold. He had the kind of music that I wanted to rap to. He's really one of my all-time favorite producers. In fact, if I had to name them, I'd go with Kanye, Marley Marl, Dr. Dre, Tone Capone, N.O. Joe, Mike Dean, and Bido (in no particular order). I really like the shit that the Neptunes and Timbaland do, too, but if I was picking a top five from the ones that I've worked with, I'd have to go with Marley Marl, Dr. Dre, Tone Capone, N.O. Joe, and Kanye. There just aren't a whole lot of producers that I really, really dig, but Kanye West is definitely on that list.

I spent a lot of time with Kanye around that time. He would come by the studio and just play records upon records upon records. We've got so many songs together from those sessions that just never came out. One day—maybe after I'm dead—I'm sure somebody's going to find all of that shit, put it out, and make a ton of money. We have records from back then that would just blow motherfuckers' minds. But I never expected him to start rapping. And then when he did, I definitely didn't expect him to be as great as he is at it. He hooked up

with Mike Dean through those sessions and now they're off traveling the world, making music together. They're both out of here. It's funny how shit works out sometimes.

I recorded the majority of *The Fix* in New York. There are so many of those sessions that I'll never forget. I remember writing "My Block" and "In Cold Blood" on the floor of the little studio we were using, just me and my engineer, while Busta Rhymes was recording in the studio next door. Or there was the time that Beyoncé was in the Sunrise Sound in Houston working on her solo debut, *Dangerously in Love*. I'd known her for years—she even appeared in the video for the one single we released on *Da Good, Da Bad & Da Ugly*, "Gangsta (Put Me Down)"—and I told her that she should do a cover of Fleetwood Mac's "Landslide." I gave her the CD and everything. I thought she could really do something with that shit. A year later, the Dixie Chicks did exactly that and their version was a smash. We had a big-ass laugh about that, but I'm sure it would have been a huge record for her. She would have killed it. And I'll never forget all the time I just spent kicking it with Jay Z. We would talk for hours.

The Fix was the first time that I'd ever done that much work on one album in New York, and something about being in that element—the energy, the history, and all of my own battles over the years to be accepted and heard in hip-hop's home—really made me step my shit up. I was determined to make something timeless and quality. Like, the fact that I was working with the same engineer who had recorded Rakim in '88 and then worked with Nas, or that the album was coming out on Def Jam with all of the history there and all of the classic albums that they'd put out over the years—it just gave the whole thing a different feel. I wanted to make sure that I made an album that lived up to that legacy and could really take its place in history next to all of the great art that had come before me. I had to bring it.

I had no idea when I was recording that album that it was going to

do what it was going to do. I just knew that it felt good, that Kanye was headed for greatness, and that I had my friends Nas and Jay Z on the same album right at the height of their feud, which was no small thing. (After Nas turned in his verse for "In Between Us," I did have to tell him to tone it down. He took some shots at Jay on the original and I didn't think that would be appropriate. He was cool about it, though, and he went back in and switched some shit up, which was great.)

Of course, it turned out the album was no small thing either. *The Fix* debuted in the top five when it was released in August 2002, and the fans and the critics loved it. I've never paid too much attention to what the media has to say about me, my music, or my life—probably because we caught so much shit from the media for our music early on—but when *The Source* gave *The Fix* a perfect five-mic rating, it just confirmed what I already knew in my heart: I hadn't turned in a slouch-ass project. I'd done what I wanted to do—deliver an album that lived up to my legacy and the Def Jam name. And I'm proud as shit of that, for real.

I only wish that Big Mello had been there to tell me what he thought of it. He'd always been the one to let me know if I really had something, but Mello had died in June after he lost control of his car and crashed on the 610 Loop. Losing Mello hurt like a motherfucker. I've lost a lot of friends, but his death fucked me up more than anything else ever has. I still can't shake that one. Curtis wasn't my best friend, he was my brother, and I just knew when it was all said and done, he was going to be right there with me, sitting on the porch drinking a cold one and talking about these days right here, making music. I dedicated *The Fix* to his memory. The way everyone loved it, I can only hope he would have been fucking with it, too.

AFTER WE'D RUN THE TABLE WITH LUDA, I COULDN'T GET DEF Jam to make another move. I had Lil' Flip lined up in the summer of 2001 and I was sure he was going to be next, but when it came time to

cut the check, Def Jam backed off and Sony stepped up. People forget but Lil' Flip did his thing, too—*Undaground Legend* and *U Gotta Feel Me* both went platinum before T.I. got on his ass. And the same went with that whole Houston wave in the early 2000s. I tried to get all of those guys—Slim Thug, Paul Wall, Chamillionaire, you name it—on Def Jam South, but we were never able to make the deals work.

Still, we had a hell of a run, and I'd probably still be there, too, if Lyor hadn't left Island Def Jam to go run Warner Music Group in 2004. Lyor was my guy, and when Island Def Jam brought in L.A. Reid to run the show, I just felt like it was my time to go. I actually didn't even take a meeting with L.A. We talked on the phone and I let him know that I thought I was ready to move on. He asked me if I wanted to come up and talk about it, but where I'm from, when a mother-fucker says he wants to get together to talk about some shit, it might mean something different. I thought he might be on some gangsta shit so I sent a few close friends of mine up there to have that conver-sation, and that was that. I was released from Def Jam. It was nothing against L.A. I just didn't think we would be a good fit. He's a pop guy, and he's great at it. He makes smash records. Just look at what he did with Mariah Carey's *Emancipation of Mimi*. You can't take anything away from the man. It just didn't feel like me.

Looking back, maybe I should have taken the meeting with L.A. myself. I could have seen what he was all about, and if I hadn't liked what I'd heard, I could have still walked away. And after I saw him judging on *The X Factor*, it was like, *Man, L.A. don't want any trouble anyway*. But I was already gone by then.

At one point, it looked like I might do an album with Sony. They'd stepped to me shortly after *The Fix* and put some money on the table. It wasn't a million-dollar deal, but it was close. But I walked away from that, too. And believe it or not, James was back in my ear, talking about how I could come back to Rap-A-Lot and how we could make

something work. After seeing the success I'd had at Def Jam South plus the experience I'd gained, I thought there might be a role for me at Rap-A-Lot that went beyond me just signing as an artist.

I have to admit, I wasn't exactly leaping at the opportunity, but I still respected James. And I thought maybe we could make something work. I thought maybe if I could work alongside him instead of for him, we could bring some integrity back to the brand that I'd helped build. Maybe everything I'd been through had set me up to really capitalize on this next move. Maybe we could really make it work in a way that worked for both of us. But that wasn't how it went at all. Not even fucking close.

UNDERGROUND RAILROAD MOVEMENT

I've got all the talent in the world—and the accolades to show for it, too—but when it comes to the business of the music business, I failed myself. I didn't move on opportunities and possibilities that were put in front of me, and I think in the end that's what held me back. I had a great experience in my time at Def Jam, probably the best experience I've had in my career. After getting a taste of that kind of working environment—with that kind of support system and financial reward—it's hard not to think about what could have been if I had moved to New York or L.A. when I was younger and when I really had the opportunity to go.

Like, I remember when we were on tour with Public Enemy, I ran into Lyor Cohen in the restaurant of the hotel we were all staying at in Baltimore. He was working at Rush Management at the time and managing P.E. I don't know what he was doing in town for that par-

ticular show, maybe just showing up to show face, but I think Craig Kallman was there, too. They weren't shit to me back then, but we got to talking, and it came up that there might be an opportunity for me at Def Jam as a solo act.

I didn't have a solo deal at the time, and the only obligation I had to Rap-A-Lot was as a member of the Geto Boys. Lyor didn't come right out and say, *We want to sign you*, but I definitely remember the number that came up—$250,000. That was an unheard amount of money for me at the time and there wasn't anything that was going to stop me from signing, but I opted out and walked away. My loyalty wouldn't let me leave Rap-A-Lot. They say hindsight is 20/20 and it's no lie. I wish I would have had that kind of vision back then because knowing what I know now, I would have taken that deal right then and there, made my solo career at Def Jam, left Rap-A-Lot and Houston behind, and never looked back.

WHEN I LEFT DEF JAM SOUTH, I HAD NO INTENTION OF DOING any more Rap-A-Lot business. You know how the saying goes, *Fool me once . . .* Well, I wasn't trying to be play myself for a fool. Besides, I wasn't fucking with the label anyway. Not when they were busy pulling the kind of bullshit they pulled with that *Balls and My Word* album in 2003.

I guess they were trying to cash in on all of the love I'd gotten for *The Fix* by pulling together a collection of old records and outtakes that they'd found lying around the studio, but I didn't have shit to do with that album at all. They didn't ask for my input on anything—not the album title, not the artwork, not the songs. Nothing. And since I guess it wasn't enough just to put the album out on its own, they had to take some old verse of mine and some old verse from Bun B and piece together "Snitch Niggas" to make it look like we were going

after 50 Cent. Next thing you know I'm in a goddamn beef with 50 Cent that I didn't even know I was in, all over a song I had nothing to do with on an album I didn't even know was coming out. Man, listen, that whole shit was wack to me.

Of course, they turned around and pulled the same shit all over again in 2006 with *My Homies, Part 2*. Once again, another album that I had nothing to do with is in stores with my name on it. Can you believe that shit? Even if they had the right to do it, the whole thing was just so corny to me. Plus, moves like that fuck with my reputation. The fans don't know that I didn't have shit to do with those albums. They just see a new Scarface album in stores and they think it's going to live up to all of the records that I've put out in the past, but then they get it and it's some cobbled-together bullshit that was never supposed to come out in the first place. But I'm the one out here looking like my shit's fallen off. So don't be fooled. Even though both of those albums have my name on them, I didn't sign off on either one. And I definitely don't cosign them. Hell no, not at all. I'm just glad Pac's mom put a cease-and-desist on that bullshit 2Face album because otherwise that would be out there, too.

So my first priority when I got out of Def Jam had nothing to do with Rap-A-Lot. It had nothing to do with any established label, period. In fact, the only reason we were able to get the Geto Boys album *The Foundation* out in early January 2005 was that we'd all signed up for that one album without having to take on a whole new deal.

Willie and Bill were both on board, which was big for me because I'd already done a Geto Boys album without Willie and I'd done one without Bill, and I just wasn't going to do another group album without the whole group. But for *The Foundation*, we were all in. Willie was back in the country after living all over Europe and the Middle East (he'd always been a smart guy when it came to getting out and seeing

the rest of the world; he was going to Greece and shit like that when we were kids), and we had Bill back. It was supposed to be another big reunion album like *The Resurrection*. Of course, once we started working on it, it became clear that what I'd thought we'd agreed to was never going to come my way, so I kind of stepped away before it was even done.

AFTER SEVENTEEN YEARS IN THE GAME, I'D STARTED TO SEE ALL of the major record companies as nothing more than slave masters and 90 percent of the artists as slaves. Think about it. When the artist signs that recording contract, it's like signing up to work on a plantation. You're there for years, slaving away in the fields, but when the crop comes in and gets sold at market, it's the record companies that get the bulk of the profit while you're left waiting for them to cut you in, like, *Please, master, can I have my piece?* And then nine times out of ten, once the music's released, that's it—you don't even own your own shit, so when your music is out there making money in movies or commercials or whatever it is, that's going to them, and you're not seeing shit.

By 2005, I'd had enough. I didn't want to be on a slave ship anymore. Instead I wanted to take all of the experience I'd gained at Def Jam and at Rap-A-Lot before that, captain my own ship, and try to help free the slaves. I worked out a deal with Alan Grunblatt at Koch Records, and my label, the Underground Railroad Movement, was born. Really I just wanted to give some artists the opportunity to make some music with me without having to worry about some label CEO trying to come behind them and take them for all they're worth. We'd do an album together and if they liked the experience, they could come back and do another one. And if they weren't happy with it, we could all go our separate ways. At least that was the thought at the time.

The label's first release was by a group I put together called the

Product, which consisted of two dope MCs with two very different styles and from opposite sides of the country—Willie Hen from the Bay and Young Malice from Mississippi. The album was called *One Hunid* and it came out in late February of '06. Me, Tone Capone, and Bido did most of the production on there and we got Alchemist to do one of the songs, which was cool because he's always been dope to me. We had some good success with it, too, especially considering it was totally independent. It sold fifteen thousand in its first week and broke into the Top 100 on the albums chart. Unfortunately, *One Hunid* ended up being the Underground Railroad's only release.

In early 2007, I signed a letter of inducement with Rap-A-Lot and Asylum to put out my next solo album, *Made*. I thought I was entering into a true partnership. I was looking for someone to help manufacture and distribute the stuff I was putting out, not sign as an artist. But as soon as I put my name on that line, I was back in cuffs and back on the slave ship. I might as well have been dead.

Once again, it was on me. I put my loyalty ahead of my business. I thought if I signed back up, I would be coming on as more of a partner than an artist. I thought together we could really restore the label's name and get back to making nothing but dope shit. Of course, once I got back there, it was just SOS—same ol' shit. Shame on me, right? You get courted until you sign on the dotted line, and then the person who courted you is ghost. You talk when they want to talk. You meet when they want to meet. Otherwise, good luck getting any attention.

Instead of being a partner, I was just another artist on the label at the mercy of whatever needed to be done. And with that letter of inducement, all of my other ventures were shut down. I couldn't put out anything with my name or my face on it unless it came through Rap-A-Lot. Of course, I didn't know that until it came time to put out the Green City album I'd been working on with some young cats out of Killeen, Texas, that I'd met at the gym. We had that whole album

done and ready to come out through Underground Railroad and even put out a press release and everything, and then the label stepped in and said I can't put that album out with my image on it or the words "Scarface presents." How are you going to stop me from putting music out on a label that I created? C'mon. How are you going to stop me from feeding my family? But they did it. They put a cease-and-desist on that motherfucker and it never saw the light of day.

I'd always seen James as my brother and my partner. We'd been partners since we were young. We'd spent family holidays together. We'd attended each other's weddings. The music we'd made together had changed the world. I never thought he would put me in a compromising position. Come to find out, every position he ever put me in, I was compromised. I just wish I could have learned the lesson much earlier in life. It would have saved me a whole lot of grief and I would have made a hell of a lot more money. But after that deal, I got the message. James isn't a friend. He's a businessman and a capitalist. And when it came to our relationship, he did exactly what he's supposed to do—he capitalized.

So we did a couple of albums together after I signed that deal in '07, but as much as I fucked with *Made*—that's a lyrical fucking album right there; those rhymes are *intact*—after that came out that December and I saw what it was, I was done. But the deal said I owed another album, so once again I was stuck making an album that I didn't want to make, and that's what led to *Emeritus* the very next year.

I was so unhappy about the whole shit by that point that looking back at all of the promo materials around that album, you can really just see it in my face. To me that album, *Emeritus*, is the worst. I'd gotten myself into this same situation all over again and I couldn't get out of it. I felt like I wanted to sail away. Like I was ready to drift off to the other side and be done with it—all of it—once and for all.

But that was it. Once *Emeritus* dropped, I was done. I'd fulfilled my obligations and I was no longer under contract. It was late 2008 and I thought I was free. I just couldn't get anyone to believe me. It was the craziest thing. As soon as I'd get interest from another label, they'd call up to Rap-A-Lot to make sure I was no longer signed and they'd be told that we still had a deal. The same thing would happen when another artist or label would call about securing me for a feature appearance. The label would tell anyone who would listen that I was still signed. So while I'm out here telling everyone I'm a free agent, nobody's willing to take my word for it. Everyone wants to see the paperwork. Of course, every time I call the label asking for the paperwork, they're in no hurry to answer the phone or send it over, and I'm fucked. Stuck in limbo with no deal, no new music out, and no way to make any bread. Shit, I got so sick of it, one day when I was in the label's offices trying to get some straight answers, I saw the contract proving that I was no longer signed lying on a desk out in the open and I just grabbed that motherfucker, stuffed it in my pocket, and walked out the door. As soon as I had that proof, I stopped fucking with James.

I've got a lot of respect for James Prince. As much as he didn't do me any favors on the business end, it was James Prince who gave me my start and let me know that what I was saying was the shit that niggas needed to hear. And it was James Prince who changed my life.

James gave me a lot of action. *A lot* of action. So when he turned his attention away from music to focus more on boxing and real estate and whatever else he's got going on besides the label, he left me with something I could take with me and use forever. James gave me that, and I'll forever be grateful. We'll always be brothers, and we'll always be family, regardless of what our relationship is or how strained it's become.

DEEPLY ROOTED

My stepdad was more of a father to me than my father ever was. Willie and I didn't get along too well when I was growing up, because I thought I knew everything, but at least I knew him. He taught me a lot about responsibility and he made me who I am today. I never got the chance to know my real dad. My parents separated when I was really young, and I've only recently started to learn more about my biological father and his side of the family through genealogy research and shit like that.

When the slaves were released, the Jordans went to Arkansas. My grandfather on my father's side was a Chickasaw and my grandmother's name was Mildred Swift. She was from Arkansas and together they had something like thirteen or fourteen kids, and one of them was my daddy.

As I've gotten older, I've started spending more time around that side of my family, and I've learned a bit more about my daddy just from being around them. They tell me that he was a super-solid dude

and that they see a lot of him in me. They also tell me that my grandfather, my daddy, and my deceased brother, Scotty, were all womanizers. I've always struggled with infidelity, to put it lightly, but at least now I know I got it honest.

I had just turned nine when my daddy was killed. It was November 24, 1979. He was forty years old. According to the death certificate, he was shot three times—once in the arm, once in the chest, and once in the head. My daddy had been running around with a married woman and it was her husband who shot him dead. I found out that same day. Somebody heard that he'd been killed and came and told my grandmother that morning. Then my grandmother told my mother and me. I don't remember much about that day, but I remember I wasn't really affected by the news. I didn't know him so I didn't really know to mourn his loss. I don't think my mom was upset at all, which isn't too surprising. If my daddy was anything like I am with women—or if I'm anything like him—I'm sure he left a bad taste in her mouth when he left.

FATHERHOOD IS THE HARDEST THING I'VE EVER DONE. THERE isn't anything easy about being responsible for a new life. It's one of the most difficult tasks in the world. I had my first son, Marcus, when I was nineteen, and looking back on it now, I have to admit that I wasn't ready to be a father. You have to know how to be a father to be a good father, and I didn't know anything about that shit. I was still a kid my damn self, fresh out the dope game and jumping straight into the rap game.

I was young and I had money and I thought that was enough to make me a good father. I wasn't going to be able to make football practice or pick the kids up from school or any kind of shit like that, but if I could buy the kids anything they wanted and make sure they had clothes and food and all of the best toys on Christmas, what else did I need? I thought I had what it took. I thought being a good father

was about being cool and being able to provide material things. Then my career took off and I missed so much.

Honestly, I didn't realize what it took to be a good father until I was about forty. It's only recently, now that my career's settled down and I understand more about relationships and about really being there for someone, that I think I'm finally ready to be a real, good father. I've learned so much. And I've learned a lot from a distance, just by watching Marcus raise his kids. That's taught me more about fatherhood than I could have ever known on my own. Watching all of my kids raise their kids, really, has just brought home just how much being a father isn't about money or about being cool—it's about time. And I'm so grateful that now that I have some time, I'll get to be there as my youngest daughter grows up.

When I say that the music industry took my life away from me, I mean it. It took everything—my social life, my time for my kids, my chance to see all of those school plays and football games and recitals and shit like that. Everything. It really just sucked me dry. It's only recently that I've started to see just how much I missed and just how much I'm lacking in really basic things like social skills. I know how to be at a party or backstage or to take pictures with my friends and fans, but I really struggle when it comes to having real, meaningful conversations with people. I just don't have any experience. I'm not used to people wanting to hear what I have to say unless I'm onstage rapping or making music. I'm only just now coming out of my shell and learning how to deal with people. I'm only just now learning how to be a normal person.

I'm a strange guy. As close as I was with all of the guys I made music with, I'm not sure I would say that we ever really became friends. Put it this way: I have a lot of friends, but I don't really have a lot of people that I run around and hang out with. I've always been like that, always chilling. Always playing it low-key, either by myself or with a

chick. It was like that even when we were on the block. The crew was always tight. And that didn't change when we stopped hustling.

Now if I'm not playing music, then I'm playing golf. And if I'm not playing golf, then I'm probably with a bitch or coaching football. If I'm not working on an album, then I'm not making music, and if I'm not making music, then I'm not hanging out with the guys I know who make music. Shit, for the longest time, I had a studio in my house, so if I was writing a song, making a beat, or laying something down, I was probably doing it there by myself. I wouldn't hook up with Mike or Joe or Tone and them until it was time to actually make an album, and then we'd link up and knock out the shit we had to get done and then we'd go our separate ways. We were all cool and we were all friends. And we had some incredible chemistry and really fed off of each other when it came time to make music, but we just didn't get that deep with our relationships, if you get what I mean.

IN 1998, I MARRIED MY LONGTIME GIRLFRIEND, RHONDA. WE'D been together for about six years when we got married, but we were still young. I was twenty-eight, which might not sound young depending on how young you are when you're reading this, but trust me, for us it was. Having done it, I really think people shouldn't get married when they're young. When you're young, you grow up and grow apart. Later in life, you grow old and grow together. I also think marriage is an institution and if you're not on the same page going into it, it's never going to work. Without getting too into it, we grew up and we grew apart.

We should have waited because now would have been the perfect time to get married. As it is, depending on what's going on, we either love each other or we hate each other, there is no in between. But she's great, and as a mother, there's none better. I'm much more mature than I was then, but there was a lot of infidelity on my part. And while

it's easy to hang that on the lifestyle, and she forgave me in the end, I've never been able to forgive myself. My transgressions have always been in the back of my mind, like, *Nigga, you brought a baby home.* She didn't do anything to deserve that. I watched her give birth to my two sons. It was the most incredible thing I've ever seen, and then I turned around and repaid her like that. As much as I'll always love her and she'll always be a part of my life, obviously our marriage wasn't that great.

I've made a lot of mistakes—a lot of mistakes. And there are things that I look back on now and wish I could have done differently. But that's life. And that's what makes us human. All you can do is hope that you keep learning and apply the lessons you pick up along the way so you can avoid making those same mistakes again.

Still, as many mistakes as I've made and as much as I've struggled with being a good father, I never deserved to go to jail over that shit. But there I was in October 2010, just an hour or so north of Houston, walking into Montgomery County Jail to serve ten months for unpaid child support. After all of the crazy shit that I'd done and all of the penitentiary chances I took as a kid, it was unpaid child support that got me caught up in the system in the end. What's worse, it wasn't like I hadn't paid her anything! So when she took me to court (it wasn't Rhonda that I had the issue with, but another woman), all of the money I'd given her over the years didn't matter and the state stepped in and fucked me all around.

Shit. Unfortunately, as a black man in Texas, once the state got involved, you already know I was fucked. So that's why I always say to these young fathers out here, if you've got a financial responsibility for your child, don't pay the mother directly. Pay that shit to the state and have the state cut her a check so it's always on the record. You don't want to end up in a situation like I did, when the kids are all grown and then the state gets involved, because the state will always see it her way. It definitely did in my case.

I'll tell you something about jail, too: getting that sentence is the beginning of some real tough lessons in just how fucked up people can be. Ask anyone who's been through the system and they'll tell you the same thing. Jail will teach you everything you could ever want to know about humanity's worst traits. I'm talking across the board, not just when you're inside. From the way some of your friends and family react when you're sentenced to the state's general disregard for you as a person and as a man on down to the whole prison-system structure—the people in charge, the guards, your fellow inmates, you name it. That shit is dark as fuck and it ain't no motherfucking joke, either.

And when you see that shit firsthand and then you think that one in three black American men will go to jail at least once in their lifetimes—and have their relationships all fucked up and their records permanently compromised as a result, making it more difficult for them to get jobs and housing and loans and all sorts of shit like that—you can't tell me the American legal and prison systems aren't part of a systematic effort to keep the black community down. You can talk all of the civil rights movement shit you want, but when you look at what's really going on today, ain't a damn thing changed but some words on a piece of paper. Sometimes I think it's even worse today. At least under Jim Crow, you could point to that shit like, *See how fucked up this shit is?* Now racism is so pervasive and spread out, it's almost like having cockroaches or some shit. You can't kill it because you can't find it everywhere it is. It's taken over the whole damn house.

AMERICAN JUSTICE

I didn't realize just how much these fucking white boys really hate us until I got to Montgomery County Jail. I always knew it, and I'd been through all sorts of fucked-up, ridiculous shit in my life to make sure I never forgot it, too. But it's one thing to experience racism in the free world where most people try to dress it up or obscure it at least a little bit, and it's a whole other thing to have the most vicious, fucked-up shit out in the open and thrown in your face on an ongoing, daily basis.

I'm telling you, Montgomery County might be the most racist, hateful jail in the entire South. Damn near everybody in that motherfucker was one of those good ol' boys your mama warns you about, and they were all sitting in one place, just waiting to spew some hateful shit. It was like some shit you only see on TV. I'm talking Selma, Alabama, and Jasper, Texas–type shit. It was like when we used to get pulled over when we were driving through these small-ass towns

on tour and they'd drag us off the bus and keep us on the side of the road for hours while they searched through all of our shit. Except this time I wasn't getting back on the bus. I was stuck in that hick town for months.

The shit that I saw there was unbelievable to me.

Like, the day that President Obama announced that they had killed Osama bin Laden, I was sitting in the dayroom watching the news. And here's Obama, our president, announcing one of America's biggest military accomplishments of the past thirty years, and as soon as Obama steps up to the podium, a correctional officer in there with me says, *They need to kick his teeth in.*

And I was like, *Shit, he just got bin Laden. Why do you want to kick his teeth in?*

He says, *They didn't really get bin Laden. That's just a publicity stunt.*

Can you believe that shit?

So I'm like, *C'mon, you really just want to kick his teeth in because he's black, right?* And he just kind of grunted, like that was what he meant but he couldn't just come right out and say it.

But that's just the environment I was living in. Surrounded by people who didn't think any black person, up to and including the president of the United States, deserved anything other than the violence they had coming to them. And the prison guards actively tried to cultivate that environment, too. The black inmates were always kept in small groups and we were always outnumbered. Like, if there was a fifty-person tank, they always made sure there were only three or four black guys in there. So it'd be the blacks on one side, kind of commingling with the Mexicans, and then a shitload of white boys, all with their shirts off, flashing their lightning-bolt, 311, and swastika tattoos. That shit was so wild to me, just to see all of these guys out here riding so hard on all of that hate.

One day I was standing near one of them. He's all tatted up, looking crazy, and we're standing there, just him and me, with no one else around. And I wanted to see if he'd just come right out and say some racist-ass shit straight to my face. So I asked him, *Man, what's that tattoo on your neck mean?*

You know how he played it? *Oh, it's nothing, man,* he says. *I've just got a lot of pride for my people. It's cool. I'm just proud.*

Proud. This motherfucker. So I tell him, *Man, you can call that shit whatever you want and try to play it off however you want to try to play it off, but I look at that shit right there as a sign of the oppressor.*

He just kind of walked away and didn't have shit to say after that, but what I told him is some real shit. And the fucked-up thing is that you don't even have to be in any kind of neo-Nazi, white-power group to exercise that *privilege.* It just comes to the select few by birth, and I really mean select few. Only 7 percent of the world's population is white. The other 93 percent is something else, but if you don't watch yourself, these motherfuckers will have you believing the lies they feed you about the white majority and how we should be grateful for the limited rights that we do have.

I call bullshit on all of that. And I honestly believe that if we don't realize what's going on and start actively attacking it, we're going to find ourselves back in captivity. It's already going on. Just look at the incarceration rates in this country and how the sentences being handed down to black defendants are so much harsher than the sentences white defendants are getting for *the same crime.* I'm telling you, this isn't a conspiracy theory. This is actual fact. We're facing a systematic attack on the black man and the black family by an inherently racist justice system supporting an inherently racist society. Just think about it. If they sentence us differently, then that means they still look at us differently, and if we don't get out there and start addressing and

fighting this shit and if these fucking yes-men in Congress don't start standing up against this shit, then we're going to be right back where we started—in shackles and enslaved.

I've got to give it up to Obama, though. I'd slap him on the back if I could just to thank him for the work he's been doing to try to address the inherent injustice in the system. The My Brother's Keeper initiative is an incredible program that's been long overdue, and I commend him for the work the Justice Department has been doing under his watch to try to peel back the laws that treat nonviolent drug offenders like they're out here killing motherfuckers (and that were basically put in place to destroy the black community). I'd started to think no one was ever going to try to make that shit right, and I'm proud of him for stepping up to the challenge in the face of all of that hate and opposition, taking it on, and making some real change. I love him for it.

Unfortunately, the family court is a whole other issue. The way they handle these child-support cases is just insane to me, and I feel like as black men, we're really getting the short end of the stick. It reminds me of the plantation all over again. When the woman goes to court, it's almost like she's seeking a savior from the white system. She's so mad that she wants to punish her man, and the judge or attorney general is happy to step in and play that role. The state then levies these fines and jail sentences to punish and emasculate the black man in front of the woman, and it's just a vicious cycle that undercuts the black family structure and breeds nothing but animosity and hate between everyone involved.

I just don't understand how you can order someone to pay, let's say, six dollars a week, but if he can't get his hands on that six dollars, then he gets locked up. But how are you going to lock me up if I only have five dollars to my name? Then, after you drag the man all through the

mud, nine times out of ten, he's going to stand up muddy and pissed and tell that woman straight up, *You know what? Fuck you and the kids!* And I just don't see how anything was solved. The family is frayed, there's a good chance that the man doesn't want to be in the picture anymore, and the woman and the child are left with only the state to protect them—and it's no secret that the American state doesn't give a shit about a black woman and her kids. Then the kid grows up with an estranged father who's been dragged through the mud and thrown in jail and the cycle just continues. It's a real American tragedy that happens every single day all across the country, and on that day in 2010, it happened to me.

But I'm not sure what hurt worse—going through all of that shit, or the one phone call that I made to James right after they locked me up. One of the deputies was cool enough to let me use his phone and I called J to see if I had any money coming or if he could somehow help me get out of the situation I was in. And you know what he hits me with? *Let me see.*

He says, *I don't know if I can do that, man. Let me look at it again, just to make sure, but I'm not sure there's anything I can do.*

And right then was when I knew I'd been confused all along. He really had me going. We'd never been friends, and that's how he won. So in that moment it was just like, *Damn, my nigga. I'm in jail. You're really going to do me like that when I'm in jail?*

All of that shit could have been resolved if I'd simply been paid for the records I'd sold. But instead it was always the runaround. Always the runaround. Well, eventually, the runaround ran my ass right into jail.

You're uncomfortable in there, he says to me. Then, instead of offering to help, he says, *Well, you should have come to the award show with me, you know? So let me see.*

Let me see. Apparently, because I'd felt like the VH1 Hip-Hop Honors: "Dirty South" show was wack and just another attempt to sideline southern rap music instead of stacking me and the rest of the artists down South against all of hip-hop, I'd jeopardized my freedom. I couldn't believe that shit, but there it was. So I sat in Montgomery County for the next ten months. IDIOT!

GUESS WHO'S BACK

I got out of jail in August of 2011. Of course, I had lawyers' fees to take care of, but that came right out of the little bit of money I had coming to me from a deal they'd had me do while I was locked up. Apparently Chrysler wanted to use a beat I'd produced for the Geto Boys song "G-Code" from *The Foundation* album for a commercial they were doing for the Chrysler 300 starring Detroit Lions defensive tackle Ndamukong Suh. This was part of Chrysler's national "Imported from Detroit" campaign, not a local spot, but when the lawyer came to see me at Montgomery County with the paperwork, he didn't come with the full contract, he just came with the release for the use of the song. The contract gave me $15,000 for the song's use, but signing it meant that I couldn't make any additional claims. I also had to sign it right then and there or the deal wouldn't go through. Well, shit, I signed the paperwork, and when I got out, that $15K just went right back to the lawyer who had done the deal. And I guarantee you that deal was worth more than $15-fucking-K.

It's just like my eighty-six-year-old grandma always said to me, *There ain't no love in the game.* Ain't that the damn truth. In this business, there's no such thing as *your people.* Your homeboy—or your friend or your partner or whatever the fuck you want to call him or you think he is—ain't that. Don't wait until you're fucked off and not generating any income because you'll be dead to them and it won't matter, not one bit, that that's the exact moment when you need them the most.

Crazy as it sounds, being in jail wasn't even my lowest point. I actually got some much-needed rest. See, I'm a hustler first and foremost so I know how to get some money. And I ain't no motherfucking punk. So even though J hung me out there, I had other folks I could call to hold me down. My phone never got cut off and I always had money on my books. And I had a new ride waiting for me when I got out.

You've got to understand, I came up in these streets. This is my game. So even though I was back to zero when I came home and I had to start over, there ain't no hard feelings. It's when you're in those situations, with your back against the wall, that you see motherfuckers' true colors. There will be a few people who stand up to hold you down no matter what, and everybody else will be nowhere to be found. You just have to take note of who has your back, pick yourself up, and get back to work. And the faster you realize that, the faster you'll get back to where you're really supposed to be.

ACKNOWLEDGMENTS

Scarface

I want to take this time to thank everyone that has been a part of making my life a story. From the bottom of my heart, I want you to know that I'm grateful—good or bad. There are too many names to name. You know who you are.

No you, no me. . . .

Thank you. . . .

Or fuck you. . . .

Pick one.

Benjamin Meadows-Ingram

First and foremost, thank you, Scarface, for giving me the opportunity to work with you on this project and for trusting me to tell your story the way you wanted it to be told. It was an incredible experience and a true honor. Your unwavering dedication to your craft has consistently set such a high bar for the game and inspired and influenced so much of my own life and career. You deserve

all of the roses coming your way, and you deserve them all today. Thank you.

To Robert Guinsler at Sterling Lord Literistic, thank you for bringing this project to my attention and for pushing me to see it all the way through, no matter what. Much respect. Thank you to Mark Chait, Denise Oswald, Elissa Cohen, and the Dey Street and HarperCollins teams for believing in this book and for giving us the time and space to get it done right. Thank you Omazelle, Uncle Eddie, Tone Capone, Mike Dean, Willie D, Bun B, and everyone else who shared their time and perspective. The book is so much better for it. To Chonita Floyd of 6307Agency, thank you for your patience and support. To Nathan Wertz of NW Transcription, I couldn't have done it without you. To the staffs at *XXL*, *The Source*, *VIBE*, and *Complex*, plus all of the other hip-hop websites out there, this book wouldn't have been possible without your tireless dedication to taking hip-hop, Scarface, and the Geto Boys seriously and to documenting the music and the culture as a three-dimensional global force from day one. Don't ever stop. To Lance Scott Walker, Peter Beste, and the rest of the team behind *Houston Rap* and *Houston Rap Tapes* (Sinecure Books), thank you for laying such a strong foundation and creating such an incredible resource and archive. To Noah Callahan-Bever, thank you for pulling me into the game and for putting me on. Life changing, you already know. Thank you to Mimi Valdés, O.J. Lima, Shani Saxon-Parrish and the rest of the *BLAZE* staff for giving me the opportunity learn on the job and to show and prove along the way. The same goes to Bonsu Thompson, Rodd McLeod, Rob Kenner, Dave Bry, Serena Kim, Sacha Jenkins, Brendan Frederick, Vanessa Satten, Rondell Conway, Rob Markman, Jon Caramanica, Sean Fennessey, and the rest of the *XXL*, *VIBE*, and *Mass Appeal* edit staffs through the years. To Alex

Gale, Steven Horowitz, and my friends at *Billboard*, thank you for opening up the archives and for always offering to help. To Shea Serrano and Sama'an Ashrawi, thank you for your early support and help with all things Houston. Thank you to Evan Auerbach at UpNorthTrips.com for digging in the vaults and sending so many classic gems my way. Thanks to Jayson Rodriguez and Nancy Byron for coming through in the clutch and to Sam Hockley-Smith for the extra set of eyes, close read, and late-stage encouragement. To Danyel Smith and Elliott Wilson, thank you for everything, always. Your support and friendship means the world. To Kachina, your counsel along the way was invaluable. Thank you. To all of my friends, family and co-workers, you guys are all awesome and I'm excited to see you all again. (Ha!) And to Ileana, your steady optimism and unshakeable confidence is always such a bright light, even on the darkest days. Thank you for everything and more.

ABOUT THE AUTHORS

Brad "Scarface" Jordan has released eleven solo albums and seven albums with rap pioneers the Geto Boys. He is an artist, producer, and record executive, the former president of Def Jam South and the bestselling hip-hop artist in his home state of Texas. He lives in Houston.

Benjamin Meadows-Ingram is a writer, editor, and content producer who got his start writing about hip-hop in the 1990s. He has held several prominent editorial posts through the years, including music editor at *Billboard* and executive editor at *VIBE*. Originally from Memphis, he now divides his time between New York, Los Angeles, and the deep South.